ARTLIFE

ARTLIFE

LAWRENCE RINDER

SELECTED WRITINGS

1991-2005

GREGORY R. MILLER & CO.

NEW YORK

Copyright © 2005 Lawrence Rinder
Published by GREGORY R. MILLER & CO., New York

All rights reserved. No part of the contents of this book may be reproduced
without the written permission of the publisher.

GREGORY R. MILLER & CO., LLC
62 Cooper Square
New York, New York 10003

Available through D.A.P./Distributed Art Publishers, Inc.
155 Avenue of the Americas, Second Floor
New York, New York 10013-1507
Tel.: (212) 627-1999
Fax: (212) 627-9484

Design: Claire Williams and Charlotte Strick

Printed and bound in China

Library of Congress Cataloging-in-Publication Data:

Rinder, Lawrence.
Art life : selected writings, 1991–2005 / Lawrence Rinder.
 p. cm.
ISBN 0-9743648-2-7 (alk. paper)
1. Art, Modern—20th century. 2. Art, Modern—21st century. I. Title.
N6490.R545 2005
709'.04—dc22
2004031029

Dedicated to

Guy Davenport,

Charles Allcroft,

Suzan Frecon,

Group Material,

Nayland Blake

and

Josef Helfenstein

——

The people

who taught me

what art

can be.

ART LIFE | Preface by Bill Arning

READING LARRY RINDER'S IMPRESSIVE COLLECTION OF WRITING ON ART AND culture has had a disconcerting effect on me. I could not stay focused on his observations, opinions and anecdotes, and I pride myself on being able to concentrate in the least advantageous of reading situations. It was not that these texts were confusing or deliberately obscure. Even read en masse, and despite the complex demands Rinder needed to satisfy in writing on visual subject matter, each piece is thought-through and clearly expressed. Yet I was consistently aware of my own nettlesome distractedness.

The problem was that I found myself involuntarily and repeatedly thrown back to my own encounters with the works in question. I remembered with a newfound clarity the initial effects these artists had on me.

I was compelled repeatedly to put down the packet of Xeroxes and stare into space. I have been blessed with a bizarrely spatial visual memory. If I remember an artwork, I will usually remember where I first saw it, what the room it was in looked like and how many people were there with me. These memories rarely have all the factual components in place and I need to consult an outside source to remember the larger context, requiring a trip to my bookshelves. For example, the Carnegie International and a Lower East Side storefront can blur together in memory, but the distance between the art object and the window will stick. The percentage of my designated reading time I spent mentally walking through long-past exhibitions seemed to increase the more I read.

I knew that this effect could not merely be due to the fact that Larry Rinder and I have similar biographies—both white, gay males of a certain age and sensibility, with some overlap in our résumés and circles of friends. Of course, there are too many writers on art who also share those qualities for this alone to be the cause of my self-absorbed response. In fact, over-familiarity with writers' milieux and haunts—and god-forbid a few shared personal entanglements or a history of running into them in nefarious locations—

and I am more likely never to identify with a word they write. The more I think I know of their lives and sensibilities, the more such facts become the "grains of salt" with which I read their writings.

If I felt I was reliving my own first encounters via Rinder's accounts, I was also clearly wrong. I had not, in fact, experienced firsthand all the artworks I was reading about in this collection of essays. Avery Preesman is totally new to me, and Theresa Hak Kyung Cha is an artist I have read about but whose work I have rarely experienced in person. (In the week after reading Rinder's text, Cha's work came up three times in conversation, a clear sign from the heavens that I need to pay attention.)

It would be wrong to pretend that I am always in agreement with Rinder's opinions or interpretations. When any writer on art reads another's work, the most one can hope for is to be in agreement with that writer a majority of the time. While I am definitely in sympathy with Rinder's tastes more often than not, I did find myself disagreeing with him on occasion. When I disagreed with his take on an artist, it was usually because I found his interpretive stance perversely chosen—such as approaching Luc Tuymans's paintings via the gothic. But perverse choices are something I greatly admire. So, again, my sense of returning mentally to my own history while reading Rinder's essays must have been grounded elsewhere.

I then wondered whether it was Rinder's compelling use of colorful anecdotes that caused his writing to induce retrospective reveries in me. His hilarious, finely rendered details of visiting Louis Bourgeois indeed bring us closer to knowing this legendary artist and character. But Rinder's descriptive strength, a rare enough gift, does not measure the limit or scope of his achievement with this book. In the essay on Bourgeois, as well as the ones on Cha and Rudolf Steiner's blackboard drawings, Rinder covers the difficult factual and explanatory material with the skill of someone used to tackling such material in front of over-confident graduate students who need to have their horizons broadened by a few inarguable facts.

The Steiner essay particularly impressed me with its ability to grant entrée to a unique body of work I have been fascinated by, but a little afraid of ever needing to discuss in public. It is a tribute to Rinder's astute explanations that on finishing the essay my first thought was a mad desire to see Steiner's works again armed with the new knowledge the essay had given me.

Since biographical similarities, shared viewpoints and Rinder's anecdotes didn't account for the effect his essays had on me while I read them, I was left with one explana-

tion: Rinder's writing expresses in many subtle and not-so-subtle ways the actual feeling of living a life fully interwoven with art. Rinder openly admits his position and situation in relation to artists and artworks. Rather than assuming the critical or curatorial voice that pretends to speak from some external position free of contradiction and uninflected by the particularities of sensibility, Rinder makes his critical stance transparent. Two clear examples of this authorial voice are his essays about Mark Lombardi and Fort Thunder.

In the first, Rinder links the web phenomenon Friendster and Lombardi's drawings of connections among international corporate finance figures. In the second, Rinder candidly discusses his role in the end of Fort Thunder and the artist collective Forcefield as the curator of the 2002 Whitney Biennial. In each of these essays, Rinder's voice is clearly that of a smart and fully engaged writer trying to make sense of the art and culture of his time, using each and every technique at his intellectual disposal. Rinder pulls into his writings many cultural sources, which serve to offer insight into both his subject and his own identity. That is very good news for the reader.

Many artists and art-writers of our generation began to feel, I believe correctly, that the audience was better off knowing the makers' or authors' perspective, and the omniscient voice began to feel very suspect. This was in no way a forsaking of the larger tasks of writing art history, theory and criticism. Rinder's texts are not from the school of art writing that avoids its intended subject through the over-subjective voice. For Rinder, as with the better writers of this generation, imparting knowledge and insight into the artwork was still the priority, but positions were stated in such a way as to be open to readers' arguments.

Rinder's introduction to the "In a Different Light" catalogue makes clear that this was a decidedly non-strident and nuanced position. The catalogue and the accompanying groundbreaking exhibition were a productive collaboration with the artist Nayland Blake that marked the first time in history that gay and lesbian artists could say, "This is who I am and it may help you understand why I make these things." At the same time, the universal spectator—the unsexed, ageless, un-raced and un-classed art-viewer—was exposed as a pernicious myth that hid many of the prejudices of standard art writing. Rinder's writings reflect, and help to usher in, that generational shift.

This way of writing invites active reading. Far from provoking the reader into the limited and terminal positions of either accepting or rejecting the author's claims, Rinder's mode of argument invites you into an imagined dialogue with the author. As someone who writes on art, Rinder's voice caused me to start composing my own imag-

ined essays. But I believe even non-professional readers will find themselves compelled to form their opinions into short essay form. Rinder's fundamental generosity as a writer makes it safe to assume that, when your position runs counter to his, he would welcome your challenge. It is the ultimate tribute to an author to feel licensed, as a reader, to make your own wild interpretive leaps, and that is exactly what Rinder's strategies as an author lead me to do.

The voice I experience in these writings is the voice of a respected fellow traveler. It is as if Rinder and I were together on the days he looked at the art he writes about. As I read Rinder, I feel that he is a trusted friend, and that we are tussling through run-on discussions of each show we are seeing over the course of a long day of gallery-going and museum visiting. During such art binges with cultural comrades like Rinder, agreeing is beside the point and may indeed interfere with the pleasure of the chase. The joy of such fellow-traveling is to experience art together, as a catalyst for fully engaged discussions on art and culture and life that can lead anywhere and everywhere.

Bill Arning
Cambridge, Massachusetts 2005

ARTLIFE

ART LIFE | Introduction

"The entire act open to us, forever and alone, consists on seizing, while we're waiting, the rare or multiple links, according to some inner state and what we can hear when we try, thus simplifying the world." —Stéphane Mallarmé

I WAS INITIALLY DRAWN TO ART AS AN ALTERNATIVE TO SUICIDE. WITHOUT drifting too far into a subject too maudlin for the present purpose, suffice it to say that one day in my late teens, I decided that art was the only thing worth living for. A lot has passed since then and I now see that there are lots of other reasons to stick around. That youthful judgment, however, continues to color my perception of art and also my professional attitude.

I have no idea what art is. I can't think of a less specific term in our language (except, possibly, that often-used and essentially meaningless word "modern"). Perhaps the most accurate thing one can say about art is that it describes a zone of permission. In contrast to other cultures, in which the boundaries of art are circumscribed by convention, ours allows that art can be just about anything. I needn't rehearse the absurd extremes of form that art has come to take in recent years. Anyone reading this book already will be familiar with many of them. And, like me, will be sympathetic to most.

No matter what the form, though, in our society a work of art remains a token of privilege and prestige. Even a fundamentally romantic character like me can't quibble with the dispiriting thesis of Pierre Bourdieu's book *Distinction: A Social Critique of the Judgment of Taste*, which is essentially that art serves primarily as a signifier of class. Whereas the contemporary art world of the 1960s and 70s was dominated by perhaps a dozen collectors, who were generally passionate and well-informed, today's market is crowded with hundreds, if not thousands, of art speculators. The hottest new thing is investor funds led by influential "consultants" that amass warehouses full of art to be unloaded at

a profitable moment. Art is no longer a mere token of social standing—it is capital, pure and simple.

But this is a tangent. The powerful and undeniable social and economic aspects of art are incidental compared to the fact that art, whatever it is, matters because it relates to life. If it doesn't relate to life, it may still be art, but it isn't art that matters—to me at least. I care for art that tears into the viscera of feeling and form and idea. Have you ever seen Kiki and Herb perform? That is art to me.

I am drawn to work that embodies life rather than illustrates it. We meet embodied art on equal footing; it sits squarely in the world with us. Sometimes embodied art can be turned into illustration by inept curation. When Agnes Martin's paintings are displayed as stepping stones between Abstract Expressionism and Minimalism instead of as tools for meditation (they never are), the embodied essence of the work is lost. A work of art that actually *is* is better than one that appears to be. The work's goal may be fairly modest, but if it achieves its aims through embodiment, it's likely to be engaging. Much of Minimalism, for example, is boring to read about, but the experience of it can be great. In space, it acts. It's crucial to appreciate this acting, this *work* that the art is doing.

While I think that much exceptional work has been made by artists who were supremely sensitive to the unique qualities of their given medium, this sensitivity is not what made their work great. A painting is not interesting because it is a painting. This may seem patently obvious, but there are influential art world personages who still think this way. Take, for example, a certain uptown art history professor who told me that the Biennial was okay but that it would have been much better if all the works were arranged according to medium. I can just see it: second floor, prints and illustrated books; third floor, drawings and photography; fourth floor, painting and sculpture. No, we learn nothing about life from this approach.

Then there are those who, while celebrating (prematurely, it seems) the defeat of a view of art that restricted judgments of quality to purely formal terms, simply substitute an alternative a priori criterion. I recently met a well-traveled artist who spoke earnestly of the "one true art world," a world consisting, he said, of the constellation of newly emergent international biennials within which neo-conceptualism is the contemporary lingua franca. How depressing. After struggling so hard to liberate ourselves from the constrictions of the Greenbergian canon we run like sheep into a brand new pen. It is enervating to witness the rush of young artists generating globally-informed, media-savvy, interdisciplinary works that ultimately speak to no one but curators and academics.

Meanwhile, the aura of celebrity, often tinged with scandal, continues to generate new art stars while sustaining the careers of artists whose best work was done long ago. As a curator, I am primarily interested in art, not artists. This is a position that got me in trouble at one of my museum jobs. The director tried to explain that our role must be to shepherd the worthiest talents from youth to maturity. But I wasn't buying it. As far as I'm concerned, there are no personal entitlements in art. It's the thing that counts. I don't care who made it. The one certainty that institutional "commitment" to artists guarantees is a steady upward trajectory for investors' long-term buys. Visitors to museums, where I have spent my entire professional life until now, confront works of art, not biographies. The material of a curator's craft is just these things, these works of art. The curator's responsibility is to present them so that they can matter to people's lives. Simply that. The art has work to do, and the curator's job is to help it do it (which usually means staying out of the way). In one of my exhibitions, I intentionally limited each artist to a single work, hoping to prove that artistic experience is an experience of singularity. I wanted people to look, not compare. Of course, it's not nice to be too dogmatic about such things. So I have at other times done just the opposite. That's one of the virtues of a long career and a lot of freedom—you can try things out.

Writing about art is different from curating it. There's no art involved, just words. So, really, it's incomparable. I find that the texture of an essay invites precisely the kind of questions of personality that I tend to shun in my exhibitions. Art essays that stick solely to the thing itself have a hard time being anything other than a user's manual: four legs, one top, eight screws—a table. Rather, here is a chance to speak, as one person to another. The things will have their chance for silent communion later. How do I feel about the work? What does it do to me? What was the artist thinking? Why does the artist's work matter? An essay is a chance to put it all out there. But, above all, writing is how my own thoughts reveal themselves to me. Putting one sentence carefully after another, when it is done right, is like wiping the gunk from a windshield. Put that way, it doesn't sound like such a noble craft. But it can be a very useful one.

Reading through the essays collected in this book, I can see that art has been, for me, a key to understanding the nature and nuances of life. I am quick to jump from the perception of a work to its resonance in lived experience. I would call the approach philosophical, except that I cannot by any means claim to be a philosopher. I can see, too, that I enjoy making far-flung connections, relating contemporary works to the art and thought of other times and cultures. There is no cohering methodology among these essays, and

only incidental recourse to "theory." Allusions to other thinkers tend to be more on the order of loose associations than the adoption of strict models. We tend to imagine that our thoughts are our own, and yet one's work is always part of a constellation of ideas. The stars in mine may be just a bit more scattered than most. I am as likely to touch on the aesthetic sensibility of the Maisin tribe of Papua New Guinea as I am to refer to Stephen King's typologies of horror or the psychoanalytic film theories of Christian Metz.

I write about the art I love, art that is filled with a sense of urgency and vitality, art that matters to life. Really, that is my only criterion.

IN 1924, ALBERT EINSTEIN WAS ATTENDING A BANQUET IN BERLIN. HIS DINNER partner, Count Harry Kessler, asked him what work he'd been doing lately. "Thinking," was Einstein's response. "Giving thought to almost any scientific proposition," he went on, "almost invariably brings progress with it, for, without exception, every scientific proposition is wrong." Einstein explained that due to the limitations of human thought, every abstract formulation is inconsistent somewhere. Therefore, every time he checked a scientific proposition, his previous acceptance of it broke down and led to a new, more precise formulation. This was again inconsistent in some respects, and consequently resulted in fresh formulations, and so on indefinitely. Einstein was brilliant but also profoundly humble. What were obstacles to others were to him invitations to creative discovery.

In my professional practice, I have found that it is indeed much more pleasant, and useful, to wonder than to know. Just out of college, armed with the knowledge I'd obtained, and emboldened by my newfound association with the Museum of Modern Art, I began giving lectures on modern art at high schools and junior high schools all over New York City. Typically, I'd have about forty minutes with each group of students—barely enough time to get their attention, let alone impress upon them the importance of Impressionism, Symbolism or abstraction. At first, I stuck to names and dates and the progress of artistic movements. But you try telling a graffiti-tagging, bling-bling-wearing, headphone-listening teenager why Cézanne's brushstroke is important. They jeered. The turning point came when I stopped telling and started asking. If, as Einstein proposed, every scientific proposition is wrong, just imagine the depths of fantasy embedded in what we call art history. So I simply let the students decide. Good brushstroke or bad brushstroke? Too much color or too little color? And so on. Far from sacrificing the historical canon I was being paid to teach, I found that the students themselves had eyes as good

as—if not better than at times—any of the critics or historians I had dutifully read. By making the image a starting point for a collective discussion, I transformed my own teaching style from insistent dogmatism to fruitful speculation.

One virtue of working in the New York City school system under the auspices of the Museum of Modern Art is that no one questions your approach. So I was able to extend my experiments in skeptical pedagogy to rather marked extremes. One strategy was to mix together slides of fine artwork from MoMA's collection with images I had shot a few nights before off the TV or from neighborhood billboards. It was fascinating to see how this awakened the students' interest as well as their own sophisticated form of visual literacy. They had a keen sense of how to read and analyze advertisements, so it wasn't difficult to shift their focus from the manipulation of desire in a Nike ad to seductive distortions in a Picasso nude. Another even more radical pedagogical strategy I tried—admittedly only once—was to begin my slide lecture by suddenly tossing all of my carefully arranged slides into the air and then developing the talk according to the order in which the images were retrieved from the floor.

During my MoMA years, the disruption of fixed categories or chronologies was more a tool to gain the students' attention and open up possibilities for their creative interaction than it was a critique of those categories or chronologies per se. The more time I spent in the art world, however, the more I came to believe that the basic structure by which we define, teach, exhibit—and even see—art is indeed fundamentally flawed. There are many powerful concepts and categories that structure the peculiarly amorphous field we know as art. Art itself, we learn, is to be distinguished from craft. You are not likely to find a woven Pomo basket displayed alongside an oil painting at the Museum of Modern Art. Then there is the matter of trained versus untrained art-making. Talented or not, in many specialists' eyes, if you have a degree in art you have a greater claim to attention than someone who made it up from scratch. Until recently, much serious thought was expended on the question of "high" versus "low" art. Works made for unabashedly commercial purposes were considered somehow beneath those made, ostensibly, for other, nobler functions.

So what? Are these questions of any consequence to those outside the field of art, or are they academic matters better left to be hashed out at the annual meetings of the College Art Association? I believe that the way we define art is indeed relevant to a broader public, not only because art is part of most of our daily lives, but also because, in my opinion, the way we define art mirrors other profound social definitions. Specifically, I believe

that what we see mirrored in the ways that the arts are defined in our society is a reflection of lingering vestiges of sexism, racism and classism. For these are the terms that lie just beneath the surface of words like "craft," "untrained art" and "low art." We have allowed the arts to become a kind of dumb show in which so-called values that would be considered discriminatory at best in everyday discourse take the stage to enact lingering myths of hierarchy. Creative works become surrogates with which time-worn dramas of inclusion and exclusion are performed.

For this very reason, these categories and definitions should not go untested. There is more at stake than the success or failure of individual careers. The ways we define and categorize art say much about our society as a whole, about our willingness to accept difference, to welcome change and to find joy in the present. And, more important, it is as much a matter for the viewer as for the curator or art historian. Museums labor under tremendous institutional inertia. Change comes slowly when there is so much at stake. For the viewer, however, change can be instantaneous, as swift as the opening of one's eyes.

I have been lucky, as a curator, to have worked at institutions that welcomed change and where my colleagues felt that there was more to be gained than lost in expanding the definition of art. I have been able to mix things up, combining materials normally kept apart, challenging conventional assumptions through how and what I presented.

An especially eye-opening project was one I undertook with a college classmate, Lafcadio Cortesi, with whom I traveled to Papua New Guinea to visit a tribe called the Maisin. The Maisin are known throughout Papua New Guinea for their remarkable tapa cloth paintings. Painting for the Maisin is a traditionally female role, and the vast majority of women spend a good portion of each day sitting around a fire, painting with vegetable dyes on tapa, a cloth-like paper that is made by pounding the bark of the mulberry tree. The Maisin paintings are neither sacred nor conventional. Each time they sit down to make a picture, the Maisin derive an image, as one painter told me, "free, from the imagination." Yet, the Maisin do not have a word that corresponds exactly to our word "art." Instead, they have the term "*saraman*," which means simply thinking and doing. Making a tapa painting that calls on the hand to respond to the free-flowing mind is *saraman*, making a canoe that requires only undeviating skill is not. At the time I visited the Maisin lands, tapa painting was undergoing something of a renaissance. New styles were being explored, and an increasing number of men were joining the women around the pots of steaming dye to try their hands at painting. One reason for this renewed interest was the

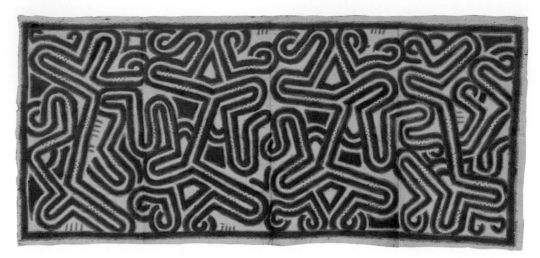

Malinda Taniova, UNTITLED, c. 1994

tribe's collective decision to use proceeds from the sale of their paintings to help fund alternatives to the sale of logging rights to their half a million acres of virgin-forested ancestral lands.

Ultimately, I worked with the Maisin to present two exhibitions of their paintings in the United States. These exhibitions, in museum contexts, called into question the boundaries between art and craft, between trained and untrained artistic practice, and—because the tapa were made for commercial markets—between so-called "high" and "low" art. Although their practice, strictly speaking, fell outside the boundaries of art as I was taught to define it, I found greater formal skill, greater imaginative refinement and far greater social relevance in their work than in virtually any other visual material I have dealt with in the well more than one hundred exhibitions I have organized.

What has made my work in the arts continually exciting and challenging and—I hope—useful, is that I have avoided resting on a comfortable bed of knowledge and instead have followed my heart to richer, if more ambiguous and challenging, territories. If, as Einstein noted, our world of definitions and propositions rests on shaky ground, this should hardly be cause for despair. Rather, it can be an invitation to a life of limitless wonders.

| Sophie Calle and the Practice of Doubt

A PECULIARITY OF OUR TIME IS THAT WHILE FEW WOULD CLAIM TO KNOW WHAT is going on, even fewer would part with their beliefs. In days past, a worldview that consisted solely of beliefs and little knowledge would have been considered a perilously fragile edifice. Today, it suffices.

A world of belief without knowledge comes into being in the absence of doubt. Actually, it's not that we have stopped doubting; we've just stopped caring. As Wittgenstein remarked about the man who doubted the existence of a table when he wasn't present to observe it: "Couldn't we let him quietly doubt, since it makes no difference at all?" Doubt, reduced to a kind of drone, may pervade our thoughts, but it rarely—if ever—disturbs the placid surface of daily interaction. If the order of the world does not add up, the mind adjusts rather than challenges.

Sophie Calle cultivates doubt. Her art is like a petri dish, growing doubts in ever more complicated and colorful designs. From the broad schemas of her works, which often undermine accepted rules or social mores, to their particular details, the truth of which it is often difficult to ascertain, Calle loves playing the skeptic.

In *The Sleepers* (1979), for example, a piece that Calle marks as the beginning of her career as an artist, she invited people—mostly strangers and a few acquaintances—to sleep in her bed while she photographed them. Based on her clinical descriptions of the project and the resulting photographs and interviews, we may dismiss the admittedly clear possibility that this piece was motivated by a desire for sexual titillation. Finally, its purpose appears to be philosophical: it is a project steeped in doubt—even propelled by it. Here, Calle has called the bluff on Wittgenstein's proverbial table, continually observing her chosen subject to see who would blink first. Does her practice of doubt also make "no difference at all?"

About this piece, Calle wrote, "I put questions to those who allowed me; nothing to

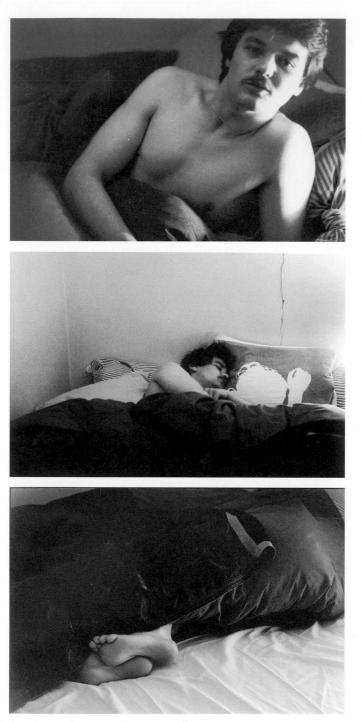

Sophie Calle, PATRICK X, SIXTEENTH SLEEPER, detail from "The Sleepers"
("Les Dormeurs"), 1979

do with knowledge or fact-gathering, but rather to establish a neutral and distant contact." Calle's work is based on a need to be reassured, but not necessarily certain, of the existence of things in the world. Her methods are analytical and precise, her gaze unrelenting. Yet, in the end what we see is not the object in closer view but the measure of the distance in between.

Calle's studied practice of doubt, resulting in a state of almost beatific disengagement, suggests a parallel between her art and the philosophy of Skepticism. The Skeptic Sextus Empiricus (first to second century C.E.) identified three types of philosophers: "the dogmatists, who claim to have discovered the object of their search; the academics, who claim that knowledge is impossible; and the Skeptics, who continue the search."

The basis of the Skeptic's quest lies not in the belief that knowledge can ultimately be found, but rather in an ongoing effort to undermine the finality of dogmatic knowing. Even those skeptics, like Calle, who seem to accept the existence of some degree of reliable information in the world, hold that information at arm's length, in a "neutral and distant contact." The Skeptics called this suspended judgment "*epoche*," a state of mind to be cultivated as part of a harmonious life.

Calle's version of a harmonious life may strike some as rather daring. At one point in her youth, prior to becoming an artist but clearly with an artist's sensibility, Calle engaged in military training with a radical Palestinian group in the Middle East. She did so, she recounts, not because of any fundamental belief in the group's values but simply to see what the experience would be like. She has traveled the world with this same bemused disengagement, taking on roles that suited the place and time and then moving on. It is not surprising that her real-life passion is the bullfight, in which the spectator is repeatedly reminded of the tenuous certainty of power and the tragic, potentially fatal outcome when there is a twist in the rules of the game.

The dangerous aspect of Calle's pursuit becomes quite pronounced in *The Hotel* (1981), in which she took on the role of a private detective. Calle found a job as a chambermaid in a Venetian hotel so that she could "examine the belongings of the hotel guests." The work documents her espionage, including photographs of the contents of various hotel rooms and detailed notes, including the following:

Tuesday 17. 11:20 am. I pass by room 46. I hear the woman say "I told you when we left" . . . followed by silence. By 12:40 pm, they have gone out. I go in. The first thing to catch the eye is the mind-boggling pair of shoes, under the table, that blocks out everything

Sophie Calle, THE HOTEL, ROOM 46, 1986

else. I then find the following items scattered about the room: a carton of Camel cigarettes, a pair of Ray-Ban glasses, a Sony Walkman with two sets of earphones. . . .

Even after such obsessively empirical observation, Calle remained doubtful of her subjects' identities. Her introduction to the piece reads, in part: "I observed through details lives which remained unknown to me."

As if to measure her own skepticism against an objective record, Calle asked her mother to go to the Duluc detective agency in Paris. "She hired them to follow me," wrote Calle, "to report my daily activities, and to provide photographic evidence of my existence." The resulting piece, *The Shadow* (1981), consists of the detective's photographs juxtaposed with Calle's written description of the day she was under surveillance.

This humorous work, a rare example of slapstick conceptualism, illustrates the problem of the criterion as it pertains to Skeptical argument. The Skeptic, like the Dogmatist, identifies knowledge with certainty but rhetorically challenges the possibility of ever proving the veracity of this concept. This challenge takes the form of an argument in which the Skeptic questions not the validity of the specific thing which the Dogmatist claims to know, but the basic premise, or criterion, for ascertaining this knowledge.

In *The Shadow*, Calle sets up the detective to establish, through tracking and documentation, knowledge of her own existence. There are two criteria for this knowledge: the assumption that she is unaware of being studied and the "proof" provided by photographs.

The first criterion may seem dubious, but it is implicit in the behavior of the detective. If it did not matter that Calle knew she was being tracked, why would the detective attempt to remain hidden? It is clear that he is attempting to document her in a state of being unaware: the question of how existence and innocence have come to be considered ontologically linked is a subject for another discussion.

Calle's challenge to this criterion is, of course, in place from the outset: she knows she is being followed. In her text, however, Calle amplifies her "awareness" from a passive recognition of the detective himself to an active effort to lead him, surreptitiously, on a tour of some of her favorite spots in Paris.

The second criterion, the presence of photographic "evidence," is undermined through no direct intervention on the part of Calle, but simply by virtue of the complete indistinctness of the shots produced by the detective. Not once does he capture her face in full view, and, in the majority of images, she is much too far away or obscured to be posi-

tively identified. The detective's flat-footed accomplishment begs the question of photography's veracity, a claim that has for some decades now been neatly laid to rest.

Another work that presents and challenges a criterion for knowledge is *The Blind* (1986). "I met people who were born blind. Who had never seen," wrote Calle. "I asked them what their image of beauty was." The criterion for knowing—in this case, knowing an image of beauty—appears to be the self-aware assertions of such an experience by the various subjects of the piece. We are implicitly asked to accept that blind people can have a sense of beauty—in particular, one that can be described in visual terms—because of the strength and sincerity of their descriptions of such an experience. Calle presents photographs of individuals accompanied by texts in which they describe beauty in their own terms, as well as by photographs, usually by the artist herself, which illustrate the blind persons' texts.

Calle, however, upsets this criterion—that is, that we can believe in blind people's sense of visual beauty because of their sincere statements of such an experience—by having admitted to inventing, in a 1990 interview with me, one of the units of this serial work. One response is wholly fictional: she will not reveal which. Knowing this, it is impossible to accept with certainty any of these statements or even the existence of any of these persons. We cannot, therefore, accept these propositions about beauty as forms of knowledge, because Calle has eroded the possibility of a standard criterion. If one of these statements might be false, then they all might be false. Like a true Skeptic, Calle does not challenge one certainty—in this case, that blind people can have a visual sense of beauty— by asserting an opposing view, but rather by calling into question the criterion for judgment. And, like a true Skeptic, one might say that, as a result, she achieves a sense of suspended judgment (*epoche*) that is more compelling and rich than the certitude of Dogmatic knowing.

Calle's admission to fabricating an element of this work is precisely what raises it above mundane, anecdotal interest to a level that is considerably more provocative and philosophically charged. Once we know what Calle has done, the work cannot be taken at face value. She forces us to consider its other implications, among which is its potent function as metaphor: we are all "the blind," able to construct memories of sensations we have never had, thanks to the overwhelming power of received ideas.

According to the Stoics, a school of philosophers contemporary with the Skeptics, there exist certain perceptions, called "*phantasiai kataleptikai*," whose truth is so self-evidently true that it is impossible to doubt them. This concept is the foundation of any

metaphysical belief system and, as such, was particularly unnerving to the Skeptics. In the second century B.C.E., the Skeptic philosopher Clitomachus challenged the Stoics on the grounds that, since all perceptions are screened and altered by subjective experience, there can be no criterion for distinguishing true perceptions from false ones. Once again, it was argued, the philosopher must suspend judgment and simply accept degrees of uncertainty.

Two of Calle's series, *Ghosts* (1991) and *Last Seen . . .* (1991), echo the Skeptics' attack on the notion of *phantasiai kataleptikai*. The word used as the title of the first of these series is a translation from the French, *fantôme*, meaning both a ghost in the conventional sense and a card used in museums to stand in for a missing work of art. On such a *fantôme*, one typically finds information such as the title, date, artist and so forth, as well as, occasionally, the reason for its absence. This card stands in for the missing work and, through the information it provides, assures visitors that the work still exists, although, at present, invisibly.

In *Ghosts*, Calle substituted for the standard *fantôme* a text consisting of employees' recollections of certain works that had been temporarily removed from view in the Museum of Modern Art in New York. These recollections were silk-screened directly onto the wall in the place where the paintings had hung, along with miniaturized sketches of the works, done from memory by these same employees. A portion of the text concerning Magritte's painting *The Menaced Assassin* reads as follows:

> "There's a lot of pink flesh, red blood, guys in black. The background is blue with French ironwork on the balcony, the bedroom is beige, but the only striking color is that blood painted red that looks like ketchup."
> "Large, awful. There's a pink boa around the neck of a naked woman lying on a table like a piece of lamb. That's all I remember."
> "I think it is a dim piece of art. There's nothing visceral or juicy about the way it is painted. It's just dull and dry. No meat."

These three memories indicate the range of impressions solicited from individuals who had worked in close proximity to the artwork for years.

In *Last Seen . . .* , Calle juxtaposes people's memories about absent artworks with the representations of the spaces once occupied by the works themselves. In this case, Calle worked in the Isabella Stewart Gardner Museum in Boston, where a notorious theft some

years ago resulted in the loss of a number of highly valued paintings, including works by Rembrandt and Vermeer. Because the installation of the collection in the Gardner Museum follows an unalterable plan laid down by the founder, the spaces where these works once hung remain, even today, empty. Calle's photographs depict these bizarre gaps and are accompanied by verbal recollections about the works, printed and framed to the same scale as the works themselves.

Calle's *fantômes* question the indisputability not only of the kind of reductive museum labeling that may not square with actual perceptions, but also of aesthetic interpretation in general. Her variable and contradictory texts undermine the notion that we can know with certainty anything about a work of art. We are reminded again of Wittgenstein's table. Is it inconsequential to doubt what we can know about an artwork, especially one that is not there for us to see? It seems somehow more important that we do so.

In fact, to introduce doubt into the practice of art is to pose important questions about the practice of life. Appropriately, Calle's art and life have always been difficult to distinguish. There is no work in which this is more pronounced than in *Double Blind* (1992), a videotape created by Calle in collaboration with Greg Shephard. Having known each other only briefly, Calle and Shephard set out on a road trip across America, bringing with them two video cameras, with which they documented each other incessantly and recorded their private thoughts. The cameras became omniscient witnesses, from both inside and out, giving the impression of an unusually incisive depiction of an unusually revealing love affair. However, like segments of other works, parts of *Double Blind* were created after the fact. I know because I was with them, cruising around San Francisco in the backseat of Shephard's enormous Cadillac as he and Calle struggled to write the dialogue in various scenes.

I still don't know which parts of Calle's life are fiction and which are fact. I suspect that she has lost track, too. To our world of beliefs without knowledge, she does not bring, like many other artists of our century have claimed to do, a fragment of truth with which to rebuild a foundation of certainty. Rather, Calle makes us question the purpose of knowledge itself, while demonstrating the particular pleasures of a life lived in doubt.

Sophie Calle and Greg Shephard, DOUBLE BLIND, 1992

Jochen Gerz: The Berkeley Oracle

"The poet's task is this my friend,
To read his dreams and comprehend." —Richard Wagner, The Meistersingers

IN HOMAGE TO THE QUESTIONING SPIRIT OF BERKELEY IN THE 1960S, JOCHEN Gerz's *The Berkeley Oracle* invited questions to be posted on a website, hosted simultaneously by the University of California, Berkeley Art Museum, and the Center for Art and Media (ZKM), and available internationally. Gerz's piece alludes to the Oracle at Delphi and represents the steps at Delphi photographically on the website.

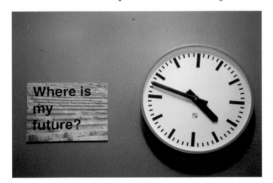

Jochen Gerz, THE BERKELEY ORACLE: QUESTIONS UNANSWERED
(installation view), 1998

Presided over by Apollo, the Oracle at Delphi was operated by women, called Pythonesses, who sat on tripods that were situated above steaming fissures in the earth. The Pythonesses, overcome by the steam, murmured sounds that were interpreted by priests. Questions of war, governance and emigration were commonly resolved at Delphi, which some, including Plato, thought left too much power in the hands of these soothsaying priests. Can the endless electronic streaming of the World Wide Web be somehow related to the steaming fissure at Delphi from which the spirit of divination was drawn? Or is it Berkeley's own Hayward Fault, a gash in the Earth more dangerous than the more notorious San Andreas? Are the students the stammering Pythonesses and the professors the pontificating priests?

I wanted to see if the questioning spirit was still alive in Berkeley today, so I walked down to Sproul Plaza on the campus of the University of California, epicenter of the

Jochen Gerz, THE BERKELEY ORACLE: QUESTIONS UNANSWERED (installation view), 1998

American radical movements of the 1960s, where I found many students quietly going about their business, sitting on the steps and enjoying the early California spring. Student information tables, the closure of which touched off the Free Speech Movement of 1964, were still there. But of twenty or so tables, only two offered pamphlets on what might be considered radical causes: The Coalition to Defend Affirmative Action by Any Means Necessary and Students Organizing for Justice in the Americas. The remainder were divided among religious clubs and associations representing Korean, Chinese, Taiwanese, Japanese and Vietnamese students. It would have seemed a thoroughly complacent environment were it not for a bearded young man who stood in the center of the plaza holding a sign that read: "Do Right and Wrong Exist?"

Gerz's allusion to Delphi leads to some interesting contrasts: *The Berkeley Oracle*, unlike the Oracle at Delphi, was not an actual place, nor did it offer any kind of response. As a website, *The Berkeley Oracle* occupied only virtual space—at least until selected questions were printed out and placed around the museum. Questions were posed, but not answered. (It is surely a unique feature of our aimless age that we fully accept the utility of asking questions without any hope of receiving a reply.) Furthermore, while questions posed to the Oracle at Delphi were predominantly concerned with the future, the vast majority of the questions posed to *The Berkeley Oracle* were concerned with the present.

If television is the sacrament, what is the religion?

What do I deserve?

Why am I here?

Doesn't the concept of infinity prove all math is wrong?

What is the nature of thought?

What can you see without eyes?

Is it time to stop caring?

Is the truth always more moral than lies?

Why is my mother like this?

These are questions about what is, not what will be. One question, in particular, epitomizes this mindset: "Where is my future?" Not "What will be my future?" but "Where is my future?" The future is not only no longer in the future (it is now), but it is (or at least the questioner hopes it is) spatially locatable (where?). The future has slipped from time into space, consisting of possibilities arrayed throughout an extensive present. Even one of the few questions concerning the future also has a spatial dimension: "Should I move to Wuppertal?" The inability to ponder a future time coincides with the skeptical spirit of our age. We don't plan; we just shuffle about, unable to commit with any seriousness to a particular perspective or point of view, un-

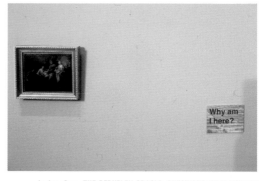

Jochen Gerz, THE BERKELEY ORACLE: QUESTIONS UNANSWERED
(installation view), 1998

willing to imagine the world as it might be. Gerz's *The Berkeley Oracle* is, finally, more a monument to skepticism than it is a reenactment of Greek divination.

Skepticism is necessary when civilization is threatened by dogma. The 1960s in Berkeley—and in Paris and Mexico City and other places—saw an explosion of skepticism in the face of calcified and therefore dangerous social and political dogma. The questioning spirit of the 60s, though, dissipated as the challenges it posed to the established system were largely absorbed into a new status quo. In principle, if not in practice, the prevailing dogma today is pacifist, pro-civil rights, pro-feminist, pro-environment. Without directly calling into question such progressive achievements, *The Berkeley Oracle* subtly undercuts the program of Liberal instrumentalism: indeed, one thing the Left has in common with the Right is instrumentalism. By neither promising nor delivering answers, *The Berkeley Oracle* steps out of politics and into philosophy, into art. Gerz invites the participants into a space of questioning and simply leaves them there. It is a space that the Pyrrho of Ellis called *"epoche,"* a state of mental suspension in which final knowledge of things is understood to be impossible.

In the spring of 1998, Gerz selected approximately forty questions from *The Berkeley Oracle*, printed them out, and placed them in various locales around the Berkeley Art Museum. Some were installed in the galleries alongside works of art, while others were tucked away in unexpected places: in the lobby, in the bookstore, in stairwells, in the women's restroom, etc. Some of them were sited in relation to their immediate environment. (In a gallery devoted to ancient Chinese ceramics and paintings: "What will happen when China invades the Western world?" On a ramp leading from the lobby to the galleries: "Where are you going?") Most of the questions, however, appeared as non sequiturs, small eruptions of spontaneous reflection in the midst of a vast concrete cultural vault.

The museum is supposed to be the home of the Muses, nine nymphs who sang in Apollo's little choral group on Mount Olympus. Like the Pythonesses, the Muses were endowed by Apollo with oracular powers. So, the Berkeley Art Museum has more in common with Delphi than one might have thought. And the questions Gerz placed throughout the museum recall our dim awareness that art was once linked to divination. Even today, we live with the persistent cliché that art foretells the future, that artists are seers. The questions hovered in the museum, as if awaiting a response from these long-dead goddesses.

Oracular pronouncements are of little value unless they are interpreted. The mur-

murings of the Pythonesses, intoxicated by the divine steam, would probably have been useless without the exegesis of the priests. The museum itself has traditionally taken the role of the oracular interpreter, or priest: organizing, attributing, dating and explaining works of art. Nietzsche, in *The Birth of Tragedy*, attributes this organizing energy to Apollo, saying: "The Apollonian power erupts to restore the almost shattered individual with the healing balm of blissful illusion." For Nietzsche, Dionysian chaos may be more "true," but it is also, by itself, incomprehensible. Meaning, indeed perhaps life itself, must derive from a balance between these two powers: the destructive flash of Dionysian insight and the self-delusion of the Apollonian dream. Both the museum and the Delphic Oracle depend on this balance. Museums, however, have become too obsessed with meaning and too orderly, more interested in answers than in questions. By placing *The Berkeley Oracle*'s questions throughout the museum and fracturing its Apollonian syntax, Gerz tilts the balance back toward the Dionysian. To have an oracle, you must first have questions.

There is a chilliness in our social space that we usually only notice when the compact of alienation is broken. Try asking a question out loud, of no one in particular, the next time you are in a crowded elevator. Try standing in a public square, like the fellow I met on Sproul Plaza, with a simple question written on a sign. You can eat a sandwich in public, tuck in your shirt, kiss or even yawn, but ask a question and most people will assume you are a lunatic. Why has wondering become an essentially private affair? *The Berkeley Oracle* website allowed us to reflect on this in solitude, alone with our personal computer. Or, in the museum, to begin to feel the stirring of something with a deeper social meaning, as if the divine steam of Delphi was again rising to the surface of the Earth.

Knowledge of Higher Worlds: Rudolf Steiner's Blackboard Drawings

A GERMAN MUSEUM DIRECTOR RECENTLY REMARKED THAT IF RUDOLF STEINER'S blackboard drawings do not fit within any current definition of art, then a definition must be devised to include them. Such rhetorical gymnastics attest to the evocative and singular quality of Steiner's pedagogical drawings, produced during his lectures on "spiritual science," art, medicine, agriculture, economics and other subjects.

Steiner was a scholar and mystic who played a major role in spreading theosophical ideas at the turn of the nineteenth century. He later founded the Anthroposophical Society to foster his own social and spiritual views. Steiner's influence today is perhaps most evident in the more than nine hundred Waldorf schools around the world that perpetuate his innovative pedagogical theories. The Camphill Communities for the mentally disabled are also an outgrowth of Steiner's work. Other areas in which his influence can be seen are agriculture (he developed the method known as "biodynamic" farming), architecture (his extraordinary Goetheanum [second version], for example, inspired Le Corbusier's monumental church at Ronchamps), and art (some of the leading figures of early twentieth century Modernism studied his ideas and incorporated them into their work). Although his organization was based at a campus-like community in Dornach, Switzerland, Steiner propagated his ideas through a peripatetic lecture circuit. From 1900 until his death in 1925, Steiner traveled extensively throughout Europe, giving more than five thousand lectures.

During his lectures, Steiner, in typical professorial fashion, illustrated his ideas by drawing on the blackboard. He typically erased the blackboards at the conclusion of each lecture; however, in 1919 his colleague Emma Stolle began placing sheets of black paper over the blackboard and then dating and storing the resulting works on paper. Except for the exposure they received in the Dornach exhibition organized by Assja Tugenieff in 1958, these drawings remained virtually unknown outside the Anthroposophical commu-

Rudolf Steiner, THE BIRTH OF THE PLANET, October 31, 1923

nity until 1990, when the archivist of the Rudolf Steiner Nachlassverwaltung, Dr. Walter Kugler, decided to publish the entire collection of more than one thousand drawings. Kugler also sensed their relevance within a contemporary art context and helped to organize a series of exhibitions in Germany, Switzerland, Austria, Japan and the United States.

Today, these drawings may appear to be compelling works of art, but they evidently did not to Steiner, nor to his contemporaries. Artists such as Mondrian, Kandinsky and Jawlensky attended Steiner's lectures and were influenced by his theories, yet none of them left any written commentary on the remarkable images and diagrams that they likely saw Steiner draw. Furthermore, although there is evidence of Steiner's conceptual and thematic influence on these artists, none of their works in any way incorporate the drawings' strikingly expressive linear gesture, high-key and high-contrast color, and combination of image and text. In fact, there does not seem to be any contemporary artistic parallel whatsoever to Steiner's blackboard drawings. Stolle's reasons for saving them are unknown. She may well have preserved them more for their ideational content than for their aesthetic qualities. Indeed, students of anthroposophy actively used the drawings at the

Goetheanum for some decades following Steiner's death as visual complements to group readings of his lectures.

The artworks Steiner made as such have an altogether different sensibility. His two-dimensional works are typified by indistinct washes of tepid color; his one surviving three-dimensional work is an enormous—and enormously unattractive—sculpture depicting Christ positioned between the anthroposophical deities Lucifer and Ahriman. Today, these works appear clumsy and derivative, whereas the blackboard drawings radiate inspiration and originality.

It is interesting to consider how Steiner himself might react were he alive today to see his pedagogical drawings presented in a museum context. To imagine his response, it is helpful to know something about his broader cosmological views and how these related to his aesthetic theories. Steiner's cosmological ideas were far-ranging and complex. In the following passage, Jorge Luis Borges's and Margarita Guerrero's *Book of Imaginary Beings* (1964) has attempted a short summary:

> The visionary and theosophist Rudolf Steiner has revealed that our planet, before it became the earth we know, had passed through a Sun stage and before that through a Saturn stage. Man is now made up out of a physical body, an ethereal body, an astral body and an ego; at the start of the Saturn era or the Saturn state there was only a physical body. This body was invisible, not even palpable, because at that time on earth there were neither objects nor fluids nor gasses. Only radiating energy was there, there were energy objects. Constellations of light determined various forms in cosmic space; every human being was just a creature of energy. Before the Sun phase, fire ghosts of Archangeloi (archangels) inspired bodies of "man," who then began to sparkle and shine. Did Steiner dream these things? Did he, because they once happened, at the beginning of time? Anyway, it is certain that these things are more astounding than the Demiurges and snakes and bulls of other cosmogonies.

Steiner himself attributed his capacity to know of such distant events to the accessibility of the Akashik Record, or world memory. He claimed to have learned of the existence of the ancient lost continents of Atlantis and Lemuria, for example, through his clairvoyant "reading" of this record; though arguably he appropriated this particular conception from Madame Blavatsky. According to Steiner, following the destruction of

Atlantis in approximately the tenth millennium B.C.E., human civilization entered into a series of epochs, each of which was marked by a further separation of humanity from nature and the spirit, and an increased emphasis on intellect and personal freedom. Steiner believed that we now live in the fifth post-Atlantean epoch that began in the fifteenth century, which is characterized by a deadening of humanity's intuitive and clairvoyant capacities. Unlike other turn-of-the-century spiritual movements, Steiner's did not generally condemn rational thinking or blame technology for society's problems. Rather, he saw these developments as essential components of a larger evolutionary pattern. His call for the development of "spiritual science" exemplifies his dialectical synthesis of seemingly opposed categories as a means of achieving a Hegelian cognitive-spiritual self-awareness.

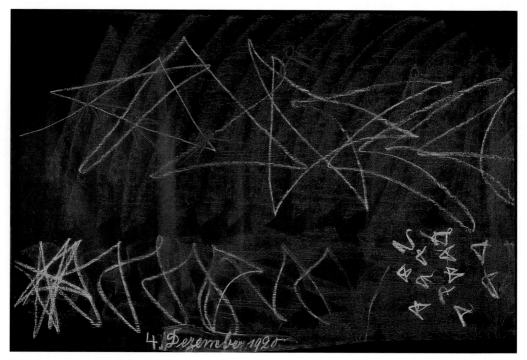

Rudolf Steiner, HEGEL AND SCHOPENHAUER, December 4, 1920

For Steiner, the appearance of Christ on Earth marked a critical turning point in the evolution of humanity. His emphasis on Christ was one of the main distinctions between his teachings and that of the theosophists, who emphasized the spiritual traditions and prophets of Hinduism and Buddhism. Essentially, Steiner understood Christ as appearing just as the influence of Greco-Roman civilization (Steiner's fourth Atlantean epoch) was

about to swing the balance of human consciousness too far in the direction of rationality and materialism. The incarnation of Christ embodied a reunification of spirit and matter.

In a series of lectures presented in 1923 and later published as *The Arts and Their Mission*, Steiner discussed architecture, fashion, dance and painting in the context of "the evolution of humanity since the time of Christ." In these lectures, he defined historically specific aims and practices for the various art forms. Art's historical specificity arose from the fact that "the cultural elements can only be understood in connection with the feelings and intuitions which people [have] out of the spiritual world." Humanity's relation to the spiritual is determined largely by the tenor of the prevailing historical epoch. For example, Steiner proposes that, while in ancient times architecture originated from "the belief that, because the soul has a certain relation to the discarded body, it can find the path into the world of spirit through the architectural forms vaulting above," the reason for architecture today is to ensure that we are "protected while eating roast beef!" In his own architectural work—Steiner designed most of the buildings that make up the campus of the Goetheanum in Dornach, Switzerland—he sought to return to an expression of the idea that "architecture unfolds out of the principle of the soul's escape from the body after passing through the portal of death."

Fashion or costuming on the other hand, were, in a more spiritual age, expressive of the beginnings of life, the "birth pole." This is because, in Steiner's view, "the world man inhabits between death and the new birth is a soul-permeated, spirit-permeated world of light, of color, of tone; a world of qualities, not quantities; a world of intensities, rather than extensions." With greater intuition of the spiritual world than we have today, the ancient costume maker created garments that "reflected something brought down from pre-earthly existence, reflected a predilection for the colorful, for harmony; and we need not be astonished that at a time when insight into the pre-earthly has withered, the art of costuming has shriveled into dilettantism." He goes on to assert, justly, that "modern clothing hardly conveys the feeling that man wants to wear it because of the way he lived in a pre-earthly existence."

Steiner based his explanation of sculpture on the rather esoteric concept that a person's head in one life is an echo, or reformulation, of that person's body below the head in a previous life. For example, the middle part of the head (e.g., the nose) corresponds to the middle part of the body (e.g., the chest) in a prior incarnation. Furthermore, what in a present life is a person's trunk and limbs will become the head in a future life. Thus, in looking at a person's body, one can have an impression of his or her past and future inter-

secting in a historically bound present. "Sculpture shows how man, through his earthly form's direct participation in the spiritual, constantly overcomes the earthly-naturalistic element, how, in every detail of his form and in its entirety, he is an expression of the spiritual."

Steiner's critique of painting in the fifth post-Atlantean epoch (fifteenth century to the present) is that "the intelligence employed in painting is a falsified sculptural one." He takes issue with the value placed on naturalistic representation and, especially, with the spatial illusionism of perspective. "A true painter," he argues, "does not create in space, but on the plane, in color, and it is nonsense for him to strive for the spatial." In place of linear perspective, Steiner proposes "color perspective." Color is the absolute essence, for Steiner, of the art of painting, and this is because "color is something spiritual." His explanation of color's spiritual engagement with the human soul relies heavily on Goethe's subjective understanding of color perception. Yet Steiner goes well beyond Goethe in proposing that colors, at least in their pure mineral (or jewel) form, are direct expressions of ancient spirit-beings. "The moment we confront a green precious stone," he asserts, "we transport our eye back into ages long past, and green appears because at that time, divine-spiritual beings created this substance through a purely spiritual green." Individual colors possess a quasi-symbolic meaning: "Red is the luster of life, blue the luster of the soul, yellow the luster of the spirit."

He also discusses "color perspective" in strictly formal terms, explaining how the dynamics of color relations alone can create a sense of spatial dimension. The medium in which the pigments are applied is of significance insofar as oils tend to "have a down-dragging effect," whereas a more fluid medium (e.g., water) allows for an expression of "the shining, revealing, radiating element." Finally, Steiner makes a psychological case for the specific role of painting: "Our feelings have no relation to the three space-dimensions; only our will. By their very nature, feelings are bound within two dimensions. That is why they are best represented by two-dimensional painting."

Although his lectures on art do not touch on drawing per se, his comments on color in painting do shed light on the extraordinary richness and evocativeness of the hues in the colored chalk used in the pedagogical works. Clearly, in making these drawings, Steiner was highly conscious of the meaning, emotional impact and spiritual resonances of the colors he chose. One cannot easily explain, however, the largely illustrational and linear handling of his medium in the terms he used to define the practice of painting with a fluid medium.

One of the most unusual aspects of the blackboard drawings is the integration of text and image. Assja Turgenieff, the curator of the 1958 exhibition of the blackboard drawings at Dornach, made the case that in the blackboard drawings, "an imaginative, colorful, flowing *Gesamtbild* [whole picture] emerged that could be experienced as a directly comprehensible, visual transformation of the spoken word." She added, "Thus, these unpretentious drawings typify Rudolf Steiner's art: they are witnesses to the manner in which art and knowledge, provided both come from the same spiritual source, can pave the way to a new culture." Indeed, the concept of aesthetic correspondences between different modes of expression does occur in another important aspect of Steiner's creative work: eurythmy. In

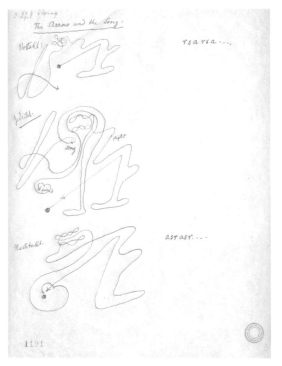

Rudolf Steiner, EURYTHMIE-CHOREOGRAPHIE OF HENRY LONGFELLOW'S "THE ARROW AND THE SONG," August 1921

eurythmy, a new dance form invented by Steiner, the dancers' movements are kinesthetic expressions of specific texts, such as certain passages of poetry, which are translated into movement according to Steiner's own idiosyncratic notational system.

Perhaps the most compelling case for understanding these drawings as art is to see them not in terms of narrow formal criteria but rather in terms of a larger conceptual schema. Besides discussing the individual art forms, Steiner articulated more general notions of the role of art in the evolution of humanity. He believed that art is one of the three essential aspects of the spiritual evolutionary path—the other two being religion and science—aspects that once, long ago, were unified. It would be the specific role of art in the Christian era to bridge the gap between matter and spirit.

Art must realize that its task is to carry the spiritual-divine life into the earthly; to fashion the latter in such a way that its forms, colors, words, tones, act as a revelation of the world beyond. Whether art takes on an idealistic or realistic coloring is of no impor-

tance. What it needs is a relationship to the truly, not merely thought-out, spiritual. No artist could create in his medium if there were not in him impulses springing from the spiritual world.

When Steiner spoke of the threefold social order comprising "science, religion and art," he was not speaking in terms of strictly defined disciplines. "Science" in this context could be translated as "cognition" or "knowledge," and "religion" referred not to a specific institution but to spiritual aims in general. Similarly, Steiner's notion of "art" can be understood as an active practice of perception and soul transformation, extending well beyond the creation of individual works of art. In *The Arts and Their Mission*, Steiner specifically addressed the need for teaching to embody the intersection of artistic, scientific and religious practices.

You see, if we really enter the spirituality of world phenomenon, we gradually transform dead abstract concepts into a living, colorful, form-bearing weaving and being. Because what surrounds us lives in the artistic, mere intellectual activity can, almost unnoticed,

Rudolf Steiner, THE REALM OF THE ANGELS, August 3, 1924

be transformed into artistic activity. That is why we constantly feel a need to enliven impertinently abstract conceptual definition, physical body, ether body, astral body, all such concepts, these impertinently rigid, philistine and horribly scientific formulations, into artistic color and form.

If I drew it on the blackboard you would see that this weaving in of color becomes a real artistic experience of the astral element of the world.

In speaking of the need to imbue pedagogical work with an artistic dimension, Steiner was not suggesting merely the kind of attractive design finesse that today's young scientists use to make their presentations more appealing. Rather, the skills he alludes to require that the instructor achieve a level of imagination, inspiration and intuition that is the mark of a self-realized being.

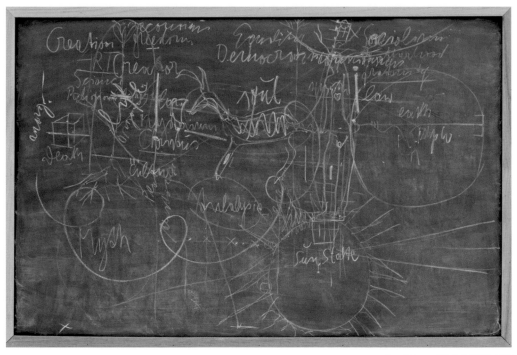

Joseph Beuys, THE SUN STATE, 1974

Finally, our ability to understand Steiner's blackboard drawings as art must be attributed, at least in part, to the work of the late German artist Joseph Beuys (1921–1986). Beuys, who is known for his "expanded idea of art" (he coined the phrase "Everyone an

artist") and the notion of "social sculpture" (which extended to his participation in the founding of the Free International University and the German Green Party), acknowledged the profound influence of Steiner on his work. Of particular relevance to this discussion are Beuys's own so-called chalkboard drawings. These drawings, collected and exhibited as works of art by numerous museums around the world, are, much like Steiner's blackboard drawings, artifacts from the artist's public lectures. In appearance, they bear an uncanny resemblance to Steiner's works, with the exception that Beuys's drawings lack Steiner's luminous and evocative use of color. For those of us who have come to accept Beuys's chalkboard drawings within the compass of twentieth-century art—albeit as highly idiosyncratic or even unique forms—it is exciting to discover the equally compelling and arguably more beautiful creations made by Rudolf Steiner more than half a century before.

I KNOW OF ONLY TWO PEOPLE BESIDES MYSELF WHO HAVE MET ROSIE LEE Tompkins: the Africanist Robert Farris Thompson and the quilt collector Eli Leon. I used

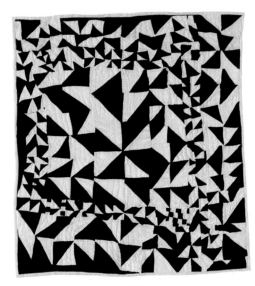

Rosie Lee Tompkins, UNTITLED, 1987

to know where she lives, in a humble house on a quiet street in Richmond, California, but it's been many years, and I'm not sure I could find it now. She is a very private woman, so much so that she will not even reveal her true name: Rosie Lee Tompkins is a pseudonym. Most museums refuse to show her work because of her unwillingness to sign loan forms or reproduction permissions. It's not that she is unwilling to lend her work or have it appear in books, it's just that she prefers to remain utterly uninvolved.

Tompkins's invisibility has led some people to believe that she doesn't actually exist. Indeed, there have been a number of notorious fake artistic personae created recently by unscrupulous dealers as a means of cashing in on the "outsider art" market. When I protested to a skeptical friend that I had actually met the artist, sat in her living room, discussed her work at length, and even gotten a hug when we said good-bye, he suggested that a woman could easily have been hired to play the role. At some point, the purported machinations of deception become even more unbelievable than the improbable existence of Tompkins herself.

None of this would matter if the works she made were not so extraordinary. The art

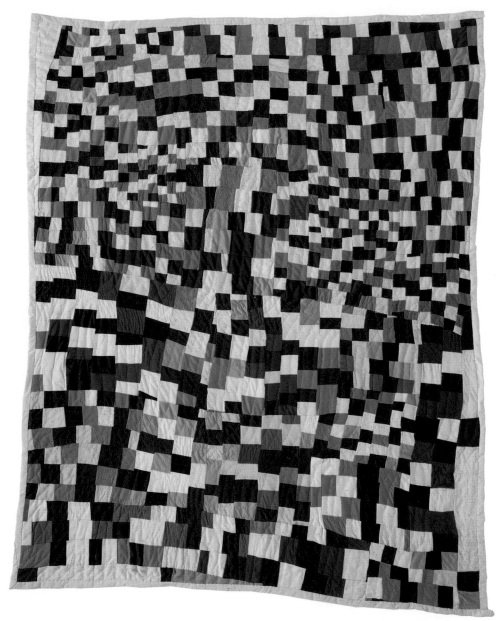

Rosie Lee Tompkins, THREE SIXES, 1986

market, always hungry for a great new talent, salivates at the sight of her singular and astonishing works. But it will not bite. Without a human face to hang these works on, without a real name and a biography, her quilts are virtually worthless. It's funny that so much value, monetary and otherwise, has been placed on the notion of the "autonomous" work of art, and yet in the face of these putatively authorless works, the possibility of direct critical judgment evaporates.

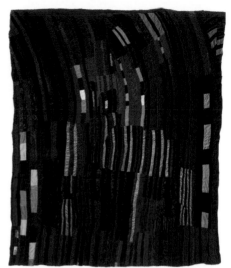

Rosie Lee Tompkins, UNTITLED (STRING), 1987

The limited critical reception of Tompkins's work has usually placed it within the context of her African-American heritage. Various aspects of her technique and style—an improvisatory method, bold color, sensuous materials, and irregular compositions—have been identified as typifying a central tradition in African-American quiltmaking. Eli Leon traces the origins of her aesthetic models to traditions handed down over generations from pre-diasporic African culture. Robert Farris Thompson has conjectured a link specifically between aspects of Tompkins's patterning and the abstract textile designs made on barkcloth in various central African cultures, such as the Kuba and the tribes of the Ituri forest. The traditional "flicker" and "disintegration/integration" patterns of these central African people is echoed, according to Thompson, in Tompkins's

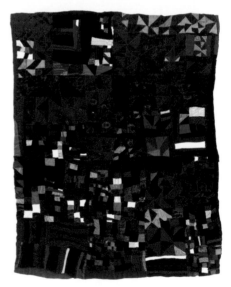

Rosie Lee Tompkins, UNTITLED, 1996

"cluster-and-scatter, bring-together-and-fall-apart manner." Conversely, others, such as Questa Benberry, have pointed to potential influences on Tompkins's work from non-African sources and have noted that, while the characteristics that one finds in Tompkins's work may be pervasive in African-American quilt traditions, they cannot be isolated as exemplifying a quintessentially African style.

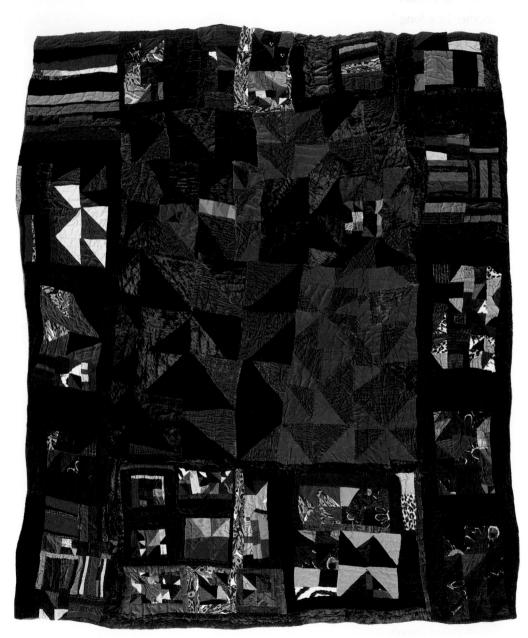

Rosie Lee Tompkins, UNTITLED, 1986

Such readings of her work depend on an acceptance of her purported biography. One must take for granted that she is an African-American woman who learned quilting from her mother in a long line of family quilters. I happen to be one of those who believe this

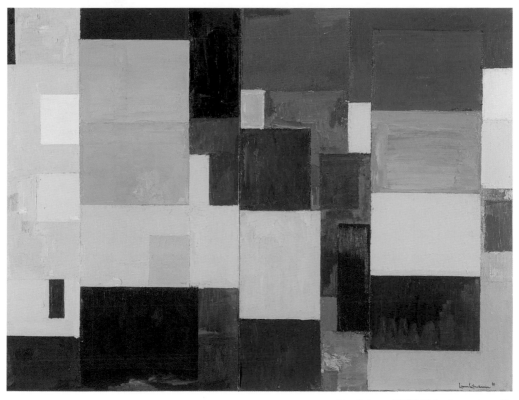

Hans Hofmann, COMBINABLE WALL I AND II, 1961

to be true, yet the ambiguity of her identity opens the door to a more complex, if problematic, reading. What if we didn't see her work in this tradition at all? How would her work be received if someone had claimed all along that Tompkins was actually a long-lost Modernist textile designer, working in an abstract tradition informed by a range of European and American styles from the Bauhaus work of Annie Albers to the Abstract Expressionist painting of Hans Hofmann and the "combine" aesthetic of Robert Rauschenberg?

One could borrow Hofmann's words, written to describe the ideal art image, for a class he taught at the University of California, Berkeley in the 1930s, to describe her work:

The picture swings and resounds to the rhythm of color, increased through integration to the highest light-intensity and richness. Tension and movement, or movement and counter-movement, lawfully ordered within unity, paralleling the artist's life experience and his artistic and human discipline, endow the work with the power to stir the observer rhythmically to a response to living, spiritual totality.

By drawing these parallels, I don't mean to legitimize Tompkins's work by absorbing it into the Modernist canon, nor, on the other hand, to revive Modernism by introducing an exotic new talent. Rather, I hope to simply discourage a complacent view that delimits her work a priori because of her purported cultural heritage and chosen medium. Tompkins's affinities to Modernist ideals, while compelling, are no less speculative than her affinities to African aesthetics. Finally, no matter in which context we choose to place her work, and regardless of whether or not we think Tompkins actually exists, these works reward extended contemplation and close analysis of their materials and techniques.

Visually, Tompkins's quilts cohere by the slimmest of margins; they jumble and burst and seem to try to twist from our grasp. Yet finally, they do cohere. Tompkins employs abstract motifs, such as half-squares, strips and medallions—which are among the traditional building blocks of African-American quilts—to bring a sense of order to her designs. Distinctively irregular in the measure of both perimeter and internal parts, her quilts gain a degree of formal stability through the mirroring of the overall design in smaller scale throughout the work. As in fractal geometry, details of her quilts echo and amplify the logic of the whole composition. Yet, a number of her works defy even these subtle approaches to formal integration, presenting instead an apparently random assortment of strips, half-squares and off-center medallions, cacophonously juxtaposed. To my eye, these are some of her most impressive works.

It should be noted in regard to composition that the traditional way of making quilts as practiced by Tompkins—in which one person designs the work and "pieces" it together while another (or several others) attaches, or "quilts," the assembled fabric to a backing—can result in effects not intended by the designer herself. Sometimes these effects can be quite dramatic. In quilting one of Tompkins's compositions, Willia Etta Graham was compelled to use a section cut from one side to build up the opposite corner in order to make the various fabrics that Tompkins had pieced together conform to a rectangular format.

In Tompkins work, color is inseparable from texture. The varied qualities of her soul-

ful blues, stop-sign reds and shimmering golds depend entirely on the type of fabric used. She is particularly drawn to velvet, a material that can simultaneously sharpen and soften the impression of a hue. Other fabrics common in her work are cotton, polyester and a special kind of glittery material that she calls "Christmas fabric." A number of her works include elements that Eli Leon calls "ties," short lengths of colored yarn that hang from the surface of the quilt to create an almost sculptural effect.

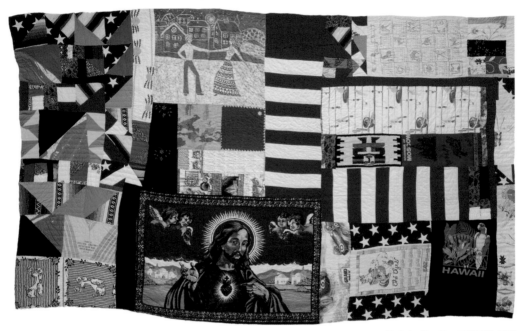

A number of Tompkins's works incorporate fabric possessing printed or woven imagery. One particularly impressive piece combines images of kittens, poodles, St. Basil's Cathedral, Jesus Christ, a parrot, racing cars, astrological figures, stars and stripes cut from an American flag, cactuses, a dancing couple and a Mexican god. This particular quilt measures more than twelve feet in length. Indeed, it must be said that the scale of Tompkins's quilts bears little or no relationship to the dimensions of a bed. Her quilts range in size from the aforementioned monumental work to pieces no more than a foot long.

When I met Tompkins, I asked her about her sources of inspiration. Each one of her

quilts, she told me, is the result of a prayer she has made to benefit a particular person, a friend, child or relative. She sees each quilt clearly before she begins. The prayer is in the making, and once the quilt is made, she has little concern for it. She is a deeply religious person and sees the hand of Jesus Christ in everything she does. She also told me that she likes to listen to music while she works and that her favorite album is the Bee Gees' *Saturday Night Fever*. No actress would have come up with that.

"The public doesn't want modern art. The public has never wanted it and never will."
—*Jack Smith*

JACK SMITH'S PHOTOGRAPHY, FILM AND PERFORMANCE CONJURE A WORLD OF campy humor, flagrant passion and morbid beauty. Going against the formalist grain of Modernism, Smith was a storyteller, a fabulist. He relished the complexities of human character and the peculiarities of human form, especially when that form was languorously posed, draped in chiffon or transformed by glitter and rouge. His devotion to art was total and, though no political activist, he insisted that art be an antidote to the spiritually and aesthetically deadening effects of American capitalist society.

Paolo Veronese (Paolo Caliari), MARS AND VENUS UNITED BY LOVE, c. 1576

Smith's photographs in particular have the rare ability to evoke in a single image an entire world, an epoch and an ethos. Deftly composing figures, costumes and settings, he created complex images that are as emotional, allegorical and strange as the baroque and symbolist art he so admired. He was inspired especially by Aubrey Beardsley's languid and often grotesque fin-de-siècle caricatures and by the paintings of Fragonard and Veronese, whose *Mars and Venus United by Love* (c. 1576) was his favorite destination at the Metropolitan Museum of Art in New York. Remarkably, Smith's sumptuous images were achieved using an extraordinary poverty of means. He photographed primarily in the confines of his own East Fourth Street apartment and used as props only materials he found on the street, purchased in thrift stores or which were given to him by equally destitute friends.

His models were not professional actors, but rather were drawn from the eccentric company of New York City's underground Bohemia. Whoever they were, though—drag queen, hustler, artist or errant Park Avenue matron—once captured on film by Smith, they were transformed into fantastic epigones of his eccentric, otherworldly vision of humanity.

In the early 1950s, Smith settled in the East Village, a working-class neighborhood of cobblestone streets and warren-like tenements that for the previous century had overflowed with recently arrived immigrants from throughout the world. When Smith arrived, the East Village was still home to vibrant Italian, Puerto Rican and Ukrainian cultures, whose restaurants, shops and street festivals created a colorful, cosmopolitan atmosphere. Smith himself was an immigrant, though he arrived from Middle America. Raised in Ohio, Texas and Wisconsin, he spent much of his youth in movie houses, entranced by the glamour and Technicolor splendor of 1930s and 1940s Hollywood movies, especially the cheesy, low-budget variety. Smith found relief from the banality of postwar American culture in the sheer artifice and ingenuity of these extravagant celluloid dreams. For him, the East Village, with its exotic mix of Caribbean, Mediterranean and Eastern European flavors, must have seemed like an unselfconscious, impoverished version of his beloved Hollywood studios, in which each culture ingeniously recreated a simulacrum of its distant origin. It was a tremendously fertile environment for Smith, and one that provided him with imagery, materials and inspiration for nearly thirty years.

At about 1957, Smith opened the Hyperbole Photography Studio in a storefront on East Eighth Street near Cooper Square. Like Claes Oldenburg's "The Store," which opened nearby in 1961, Smith's studio was less a genuine commercial enterprise than a kind of ongoing performance/installation. The unsuspecting customer who entered the shop expecting to have a portrait taken usually ended up posing instead for one of Smith's bizarre tableaux. In fact, Smith's individual photos were more like film stills than static scenes. Each roll of film, which typically accommodated twelve images, comprised a unique, unfolding drama in which the actors would be subtly

Jack Smith, UNTITLED (detail from a contact sheet), 1958–60

shifted from frame to frame, creating the suggestion of narrative. There is an air of morbidity in many of the photographs taken at Hyperbole. Certain sequences allude to suicide, ritual murder, and necrophilia; yet, despite these gruesome themes, Smith's models appear to be enjoying themselves and are often grinning.

Among Smith's photographs from 1958–1960, some of the most remarkable works are those shot in the cramped space of his own tenement apartment. These color images are extraordinary puzzles of bodies, bedclothes and a host of other seemingly unrelated items: a radio, a star map, drapes, veils, photos clipped from newspapers, and a frozen chicken. Smith used strategically placed mirrors to further complicate and fracture the viewer's perception. As if in a nod to one of the likely inspirations for his complex, synthetic compositions, Smith had one of his models hold a book open to a painting by that master of visual paradox, Édouard Manet.

Like Manet, Smith relied on the innate expressiveness of the human form and the symbolism latent in the relationships among groups of figures. The experimental filmmaker Ken Jacobs, who was one of Smith's closest friends and collaborators between 1955 and 1961, recalls Smith's early photo sessions: "People were made to look like they were in a scene from a movie. It was Jack's movie. The most important thing was to bring the actors into connection with each other. It would be redundant actually to act out. More was possible if things were left indefinite. The eccentricity of this work is the architectonics of the dramatis personae."

Like many of his contemporaries, Smith was fascinated by the visual and poetic richness of found objects. In many of his early photographs, the figures and their accoutrements combine to convey obscure allegorical meanings. In a sense, many of Smith's photographs from this period can be seen as two-dimensional assemblage. In other photographs, the relationship among the figures is wholly abstract, with bodies and limbs interpenetrating with colored fabrics and assorted props to create an allover composition not unlike that of the Abstract Expressionist painters of his day.

Jack Smith, UNTITLED (detail from a contact sheet), 1958–60

In the late 1950s, besides shooting at Hyperbole and in his apartment, Smith made numerous forays to outdoor locations. The rubble-strewn lot at Broadway and 65th Street—the spot that was to become Lincoln Center—was a favorite site. The photographs taken there present costumed figures lost in a sea of broken concrete and twisted metal bars. The dour characters in these and in his other outdoor photographs of the period, many of which were shot in Central Park and upstate New York, possess a mythical, archetypal gravity, more evocative of a grim Northern European sensibility than of the flamboyant Middle Eastern scenarios with which Smith is typically associated.

Perhaps the most profound influence on Smith's early photography was the German film director Josef von Sternberg. Smith greatly admired Sternberg's devotion to visual effect, at the expense of plot, acting or whatever else might get in the way of a compelling visual image. In his 1963 essay, "Belated Appreciation of V.S.," Smith wrote:

His expressiveness was of the erotic realm—neurotic gothic deviated sex-colored world and it was turning inside out of himself and magnificent. You had to use your eyes to know this because the soundtrack babbled inanities—it alleged [Marlene] Dietrich was an honest jewel thief, noble floosie [sic], fallen woman, etc., to cover up the visuals. In the visuals she was none of those. She was V.S. himself. A flaming neurotic—nothing more nothing less—no need to know she was rich, poor, innocent, guilty, etc. Your eye if you could use it told you more interesting things (facts?) than those. Dietrich was his visual projection—a brilliant transvestite in a world of delirious unreal adventures. Thrilled by his/her own movement—by superb taste in light, costumery, textures, movement, subject and camera, subject/camera/revealing faces—in fact all revelation but visual revelation.

In Smith's interior images from 1958–1959, there is a strong flavor of Sternberg's cluttered, shallow space, his veils and mirrors, his chiaroscuro and dramatic overhead lighting, and his sense of theatrical body language and gesture. The space of Smith's images is literally heaped with people and props, and the only relief from the clutter is in the shadows cast from one object onto another. Film theorist Carole Zucker's observation on Sternberg applies equally to Smith: "In his films we become 'crowded out;' we are not invited in to look, but only to look in on the events. . . . He disposes lines and shapes in the frame in a way that deprives human figures of their individuality and organic forms their naturalness."

In these photographs, Smith first embraced the so-called "trash" aesthetic that was to re-emerge to great effect in his later film and performance work. Jacobs, who claims to have awakened the previously fastidious Smith to the richness of this aesthetic of impoverishment, observed, "You see the actual, the banal, you see what you're stuck with and you also see the ideal. The humiliation of what you are and what you aspire to be makes the aspiration all the more glorious because there you are earthbound, and you don't have an open checkbook like you would on a Hollywood set where everything you do becomes vapid and nothing. You actually get real drama." Similarly, Irving Rosenthal, Smith's close friend and

model, recalls, "All of us had an aesthetic at that time. It was that we didn't need Hollywood, the mass media, the academic poets; we didn't need any of that. We were all capable of producing art for each other, without any money, or without much money. We were really poor and it was alright to be poor. It was our aesthetic to use whatever was at hand. Everybody went out 'junking.'"

Besides creating fantasies from assemblages of bodies and found props, Smith also exploited the extreme close-up as a means of blocking out the coarse reality that might surround an otherwise exotic face. One close-up photograph of Jacobs, shot in Smith's bathtub, has all the watery mystery of an Odilon Redon pastel. *Ouled Naiel*, acquired by the Museum of Modern Art in 1960, is a tightly cropped image of a model costumed and made up to look like a North African dancing girl. In another series of close-up portraits of the same model, Smith orchestrates costume and make-up of pale yellow, bone white, magenta and blue to create an effect of powerful beauty and allure.

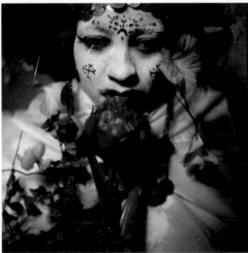

Jack Smith, UNTITLED (details from a contact sheet), 1958–60

Indeed, Smith was a pioneer in the use of color in art photography. A number of fashion photographers, including Horst P. Horst, Cecil Beaton and Irving Penn, had been publishing color photographs for more than a decade; however, until the introduction of the type-C print in 1956, exhibitions of color photographs were virtually unknown. The type-C print transformed color photography from a specialized and expensive endeavor to one available to amateurs, artists and large-scale commercial production. Smith's first one-person exhibition, held in 1960, consisted of thirty large-scale color photographs. In a remarkable debut for an unknown artist, this exhibition was held at the Limelight Gallery, the most prestigious photographic venue of the time, where such luminaries as Eugene Atget, Berenice Abbott, Henri Cartier-Bresson, Ansel Adams and Paul Strand regularly exhibited. The press release for Smith's show read, in part: "If Jack Smith's work is really appreciated, it will show up a great percentage of conservative and even dead imaginations that lurk under the guise of modern photography in this presumably mature era of the medium."

Despite his early success with color, virtually all of Smith's photography after 1961, with the exception of the photos used in his 1970s and 1980s slide shows, were black-and-white. This may have come as a result of his being dismissed as an employee of the Medo photo laboratory, where he had been able to do his own color printing after hours. Smith continued to develop black-and-white prints in his apartment and, on occasion, had commercial prints made from color negatives.

Smith staged a series of photo sessions from late 1961 through the filming of *Flaming Creatures* in the summer of 1962 that resulted in a series of exceptionally beautiful black-and-white prints. He made numerous small-format prints from these sessions— most of them no larger than contact prints—that are among the few vintage Smith photographs to have survived. In 1962, Smith and the artist Marian Zazeela developed a four-page layout of sixteen of these small prints intended for publication as an artists' project, titled *16 Immortal Photographs*, in Jonas Mekas's avant-garde film magazine, *Film Culture*. Each page contained four square black-and-white images abutted to one another to form a composite square centered on the page. Since Zazeela and Smith chose to reproduce a number of the photographs sideways, abstract relations of form are emphasized over narrative elements or the evocation of personality.

While Mekas declined to publish *16 Immortal Photographs*, Smith successfully produced, with the poet Piero Heliczer's the dead language press, an artist's book titled *The Beautiful Book* in a limited edition of two hundred copies in late 1962. *The Beautiful Book*

consists of nineteen tipped-in black-and-white photographs. Among the precedents for Smith's book are LaMonte Young's *An Anthology*, a book collection of proto-Fluxus projects that Smith helped to collate, and Wallace Berman's art and poetry magazine *Semina*, the 1957 edition of which included hand-mounted black-and-white photographic images. Roughly half of the photographs in *The Beautiful Book* feature the artist Marian Zazeela, and the printed cover design is based on one of her sketches. Smith, who met Zazeela through Rosenthal in the fall of 1961, quickly developed a passionate attachment to her, consciously modeling their relationship on that between Sternberg and Dietrich. Indeed, there is a striking resemblance between Smith's photographs of Zazeela and Sternberg's film images of Dietrich. Whether seen in reflection, half-hidden in shadow, or covered by a veil or the fronds of a palm, Zazeela, like Dietrich, is only partially revealed, an emblem of unattainable desire.

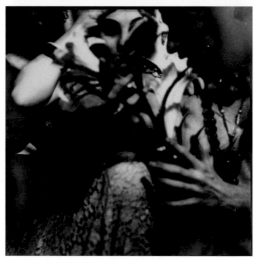

Jack Smith, UNTITLED (details from "The Beautiful Book"), 1958–60

The Beautiful Book features a number of other models, including Mario Montez, Francis Francine, Joel Markman and Arnold Rockwood (a.k.a. Pasty Arnold), who appear frequently in Smith's early 1960s photographs as well as in his films. From his earliest photo sessions in New York, Smith depended on this faithful coterie of models, whom he called his "creatures," as well as on people he seduced or paid to participate for one shooting session only. By the mid-1960s, many of Smith's models had gone uptown to join the fun at Andy Warhol's legendary Factory. Even Smith himself fell into Warhol's orbit, acting in an unreleased early film, *Batman/Dracula*. Warhol's use of the term "superstar" to describe the transvestites, drug addicts and other

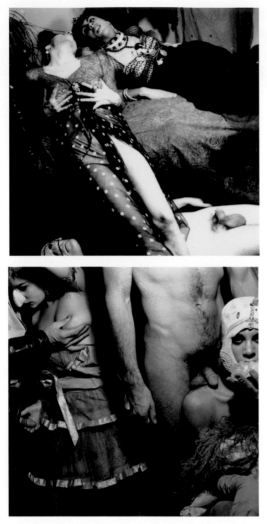

Jack Smith, UNTITLED (details from "The Beautiful Book"), 1958–60

marginal characters who appeared in his films, as well as the very idea of the Factory—an avant-garde, Bohemian simulacrum of the traditional Hollywood studio, consisting of an ensemble of essentially replaceable stars and starlets presided over by a charismatic auteur—originated with Smith's fantasy film studio, Cinemaroc, and his eccentric, though generally faithful, "creatures."

But unlike the passive and often invisible Warhol, who might make a film by simply turning on the camera and letting it run in front of some hapless subject, Smith's relationship to both his photographic and film models was highly engaged. Rosenthal, who began posing for Smith in 1961, recalls:

Jack's shooting sessions were transformative. He was a transformer of people who got the artistic effects that he got because he had the power of transforming, like a guru. Yes, he was creating works of art . . . some of us at the shooting sessions understood that. But others just came because of his transformative power. The sessions were extremely arduous. Jack was always after the essence of his models. Kind of like a shrink. People would sometimes leave crying. You couldn't trust him. He was very cruel.

The difference between Warhol's Pop-Minimalist aesthetic and Smith's more surrealistic, psychologically inflected work is demonstrated in their joint contribution to *Aspen* magazine. Known as "the magazine in a box," each issue of *Aspen* was designed by a different guest editor. The December 1966 issue was edited and designed by Warhol and

David Dalton and resembled a box of Fab detergent. Warhol's and Smith's piece took the form of an "underground movie flip-book," which can be flipped in either direction. In one direction is Smith's piece, *Buzzards over Baghdad*, which begins with Smith's textual introduction: "Mehboubeh, the slave woman, lifts the artificial elephant off the love bandit's chair . . . and creates a pasty novel." The sequence of images begins with a close-up of a rotating table fan. The camera pulls back to reveal, standing to the right, The Love Bandit, and walking across from the left, Mehboubeh. The camera zooms in as Mehboubeh reaches down to lift an elephant tusk off a chair beside The Love Bandit. Flipped the other direction, Warhol's *Kiss* consists of a single close-up shot of a prolonged kiss.

The stark presentation of figures against a white background in *Buzzards over Baghdad* is characteristic of Smith's photographic work in the mid-1960s and represents a departure from the complex and densely detailed compositions he had been exploring since 1957. The dust jacket of Irving Rosenthal's novel *Sheeper*, for example, features a photograph by Smith of the author, in which the arabesque curves of Rosenthal's caftan and turban provide a simple counterpoint to the strange organic forms arrayed on and above his dressing table. Another image from the period shows a group of exotically garbed figures whose eccentric, high-contrast outlines echo the style of high-fashion photography popularized by Cecil Beaton and Richard Avedon. One of the models in this image, the writer Isabel Eberstadt, recalls that in about 1965, Smith became obsessed with Avedon and desperate to meet him. She introduced the two at a party given by Truman Capote, but Avedon found Smith to be unnervingly intense.

The metamorphosis in Smith's photographic style and his personal ambitions parallels changes in his social and financial circumstances. By 1965, he had become a well-known figure, in part because of the legal controversy surrounding the release of his film *Flaming Creatures*. Thanks to a regular stipend from Eberstadt, he no longer had to scrounge all of his props and costumes from the street and thrift stores. Around this time, he began to imagine that he could become a successful mainstream fashion photographer. Although Smith had always been interested in fashion photography, it was only as a foil against which to develop his own highly idiosyncratic style. In the mid-1960s, though, he became fixated on having his work published in *Vogue* and made at least one awkward attempt to meet the editor, Priscilla Peck.

Despite his shifting aims, when Smith was given a one-person exhibition at the Ferewhon Gallery in 1965, he chose to show exclusively color photographs shot before 1962. Printed commercially at the time of the exhibition, approximately eighty of these

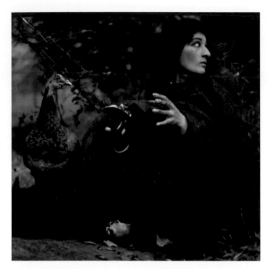

3 1/4-inch square photographs were mounted on 3 1/2-inch white wooden cubes. According to an unpublished review by Barney McCaffrey, they were "grouped in several series—each series in itself making an interesting geometric design. The groupings were based on subject matter—usually a group of shots taken at the same time in the same environment. Transition between the various series was based on several premises—philosophical (life to death), emotional (light to strong), personal (relationships of people in the photos to each other and to the photographer), and others, such as color range, composition, etc."

After 1965, Smith ceased creating photographs for display as artworks themselves, though photography continued to play an important role in other aspects of his work. From the early 1970s through 1987, Smith presented his photographs in the form of slide shows. These events, like his so-called "expanded cinema" screenings, were, in effect, multimedia performance pieces. They were remarkable for Smith's unique projection method and performance style. As the Brazilian artist Helio Oiticica remembered: "The slides displaced ambience by a non-specific time duration and by the continuous relocation of the projector framing and re-framing the projection on the wall-ceiling-floor: random juxtaposition of soundtrack (records)." Although others recall the relationship between the images and sound to have been much less random, all agree that these events were peppered with spontaneous interruptions and adjustments.

Another dimension of Smith's late photographic work is the large number of self-portraits, including conventional Hollywood-style headshots, costumed full-length poses, and collaged images in the style of film publicity shots. Ken Jacobs recalls that in the late 1950s, Smith considered trying to get work as a model, and the early portraits (some of which were shot by Jacobs) of a screen-idol handsome Smith may derive from this abortive attempt at gainful employment. Smith continued to have conventional headshots taken, even into the 1980s, long after he had stopped scouting out modeling agencies. Throughout the 80s, however, he was more likely to invite friends to meet him for ex-

tended photo sessions in which he would pose, in costume, in fabric-draped interiors or in outdoor locations around New York City. (One of his collaborators, Michael Oppedisano, recalls that on more than one occasion, he responded to Smith's invitation only to realize that Smith had not loaded the camera with film; regardless, Smith always insisted that they proceed with the shoot.) Smith used these self-portraits primarily to publicize his performances, composing and recomposing them for various formats: fliers, posters, press prints and newspaper ads. A number of the images were collaged onto backgrounds taken from stills or publicity shots from his favorite films. Re-photographing these collages, Smith was able to create an almost seamless impression of himself transported into various exotic fantasy realms. Although his work derived from very different motivations, it is interesting to compare these pieces to the work of Cindy Sherman and Laurie Simmons, who were at the time also exploring the transformation of self in film stills and the transposition of figures into alternate, found settings.

Smith's photography was appreciated by few people during his lifetime. Rather, his reputation is based almost exclusively on his films and performances. Certainly his work in these media was profoundly influential, whereas his rarely seen photographs exerted little, if any, influence on other photographers. Today, exceedingly few vintage prints of Smith's photographs survive, the victims of loss, fire and Smith's own predilection for constant transformation and reuse of his materials. Luckily, many of his negatives do still exist and, while we can generally only guess which images he would have selected to print, how large he would have printed them and how—or if—they would have been cropped, these hundreds of negatives give a fascinating view of the world as seen through Smith's singular vision.

His was a world of poverty and depravity suffused with glamour, sensuality and drama, a debased world redeemed by art. Smith's belief in the power of art to counteract the prevailing evils of American society could be dismissed as naïve and romantic, and indeed maybe it was, in social and political terms. Yet, the better world he imagined was not just an eccentric, escapist fantasy. It was a reality that he brought into being with every click of his camera's shutter. His images are object lessons in the survival of the creative spirit. Smith was one of those rare figures in the history of art, in whom boundless imagination and originality is coupled with tremendous aesthetic refinement. And it is above all in his photographs that the critical tension between flamboyance and precision is most profoundly achieved.

THE EXHIBITION "IN A DIFFERENT LIGHT" EXPLORES THE RESONANCE OF GAY and lesbian experience in twentieth-century American culture, focusing primarily on works of art made during the past thirty years. It is not a definitive survey of gay and lesbian aesthetic sensibilities but rather a gathering of diverse images and objects that sheds new light on our collective American history.

The initial inspiration for the exhibition was the dynamism and innovation evident in the work of a young generation of gay and lesbian artists. Not only has there

Zoe Leonard, WASHINGTON, D.C., 1989

been an outpouring of work in the visual arts, but, especially in San Francisco, there is a palpable sense of community: visual artists, playwrights, poets, performance artists, filmmakers and video artists present their work together in a variety of nonprofit venues and small commercial galleries, work that is often itself interdisciplinary and collaborative. These artists live in a generally hostile social climate, under the constant threat of anti-gay hate crimes and proscriptive legislative initiatives, and surrounded everywhere by the tragedy of AIDS. Remarkably, they not only persist in making art, they do so in a spirit of humor, generosity and flamboyance. Much of this work has less to do with representing gay and lesbian

lives than with conveying gay and lesbian views of the world: it is outward-looking, gregarious and socially concerned.

Nayland Blake, the artist whom I invited to curate an exhibition documenting this local, contemporary movement, believed that such an exhibition would not add much to what several recent exhibitions, including one organized by Blake himself, had accomplished. He proposed instead a cross-generational exhibition that might help redress some of the cultural amnesia to which the art world is prone. Gay men and lesbians have been especially susceptible to such forgetfulness, because art with homosexual content—whether literal, metaphorical or symbolic—has typically remained unidentified as such, or has simply been excised from the history. The contributions of numerous important artists, such as Romaine Brooks, Harmony Hammond, Kate Millett, Scott Burton, Jack Smith, Thomas Lanigan-Schmidt, Arch Connelly, Nicholas Mouffarege, David Wojnarowicz, Peter Hujar and Martin Wong, remain comparatively under-documented.

Among those who have been accorded a degree of exposure or even fame, the problem of visibility remains in a different form. A 1952 retrospective of the work of Charles Demuth at the Museum of Modern Art, for example, did not include any of the artist's extraordinary erotic watercolors depicting sailors in flagrante, nor his equally unambiguous scenes set inside a Turkish bath. Similarly, Lincoln Kirstein's 1992 catalog essay for a retrospective exhibition of Paul Cadmus at the Midtown Payson Gallery makes only veiled reference to homoeroticism in Cadmus's paintings, though this is arguably his work's most distinctive thematic feature. We can debate whether identifiable gay or lesbian aesthetic sensibilities exist; however, we certainly cannot clarify the issue so long as important artists remain closeted—either by their own or by others' efforts.

Catherine Opie, SELF-PORTRAIT/CUTTING, 1994

The historical contributions of lesbian artists, meanwhile, have been doubly obscured: first, as women; second, as homosexuals. While the feminist movement of the 1970s forced a grudging acknowledgment of women's contributions to the history of art, many activists in this movement embraced mainstream acceptance at the expense of visibility for overtly lesbian art practices or interpretations of women's art that might reflect same-sex desire.

We developed "In a Different Light" by imagining groups of images and objects that through their juxtaposition might engage refreshing and provocative dialogue. Often, such groups would coalesce around a few key works. For example, Nancy Grossman's hermetically sealed *Head*; Arch Connelly's glamorously solipsistic, pearl-encrusted *Self-Portrait*; and Scott Hewicker's plumply pillow-like *Someday He'll Make It Plain to Me* seemed, through a process of poetic association, to be somehow related. From this core, we expanded the group to include D. L. Alvarez's ephemeral *Shawl*, Man Ray's classic Surrealist photograph *Enigma of Isadore Ducasse*, Catherine Opie's visceral *Self-Portrait/ Cutting*, and Joan Snyder's abstract, impastoed *Lady Blacklines*. This grouping, which ultimately became a section of the exhibition titled *Self*, evokes two central and compelling themes: a sense of self that is alienated yet autonomous, and an approach to craft that is highly tactile, a fastidiousness bordering on compulsion.

As we added more such groups, compelling cross-references and common themes emerged. It became a crucial challenge to maintain coherence and comprehensibility within each group while allowing for a lively and open play of meaning. We began to look for characteristics of each group that might be brought forward in the form of titles, thereby allowing us to frame and focus our selections. We settled on a series of nine groups: *Void, Self, Drag, Other, Couple, Family, Orgy, World* and *Utopia*. These function individually a bit like intimate chamber plays—somewhat in the manner of San Francisco playwright Kevin Killian's low-budget productions, in which a variety of members of the local arts community are enlisted to perform: each person, or in our case artwork, retains its inherent identity while taking on, in the ensemble, a new role.

The order of the groups suggests a progression, mathematically, from zero (*Void*), one (*Self, Other*), two (*Drag, Couple*), many (*Family, World*) to infinity (*Orgy,*

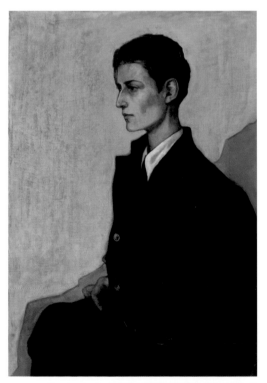

Romaine Brooks, PETER (A YOUNG ENGLISH GIRL), 1923–24

Utopia). This progression expresses an experience of moving toward ever greater degrees of sociability. On the one hand, this trajectory alludes to the historical development of the gay and lesbian communities from a condition of isolation and invisibility through a developing sense of community, to the present condition of increasing integration. On the other hand, the progress of the groups can be read as an individual's—any individual's—passage from alienation to integration.

The progression of groups in the exhibition is not chronological, as each group contains works from a variety of historical periods. Culture in general, and gay and lesbian culture in particular, interprets and reconfigures the past in terms of the present. In this exhibition, history reads both ways, recontextualizing older works in terms of their present resonances and positing contemporary works in terms of their continuity with historical traditions and sensibilities.

The notion of sensibility that we have employed is somewhat idiosyncratic. The groups are not based on aesthetic sensibility, but rather came together and are identified by social sensibility—that is, the various conditions of being in the world in relation to other people. The exhibition is thus structured in a fundamentally sociological rather than art historical manner. While aesthetic sensibilities as such are not a point of departure or structuring principle, such sensibilities certainly emerge in interesting ways throughout the exhibition.

What would a lesbian or gay aesthetic sensibility be? For lesbians, the social revolution of the women's movement in the 1970s brought unprecedented opportunities to present and examine their art in the context of sexuality. However, as Harmony Hammond, curator of the historic 1978 exhibition "A Lesbian Show," recalls, the result was not the discovery of a distinctly lesbian aesthetic sensibility but rather the revelation of a broad variety of shared thematic concerns, including "issues of anger, guilt, hiding, secrecy, coming out, personal violence and political trust, self empowerment, and the struggle to make oneself whole."

If it is true that, by 1980, no distinctly lesbian aesthetic had emerged, the phenomenon of "camp" had long before entered the mainstream academic discourse as the token legitimate sensibility identified with homosexuality (typically, though not exclusively, male homosexuality). In her 1964 essay "Notes on Camp," Susan Sontag wrote, "The hallmark of Camp is the spirit of extravagance. . . . Camp is art that proposes itself seriously, but cannot be taken altogether seriously because it is too much." Building on her observation

that "every sensibility is self-serving to the group that promotes it," Sontag states, "Homosexuals have pinned their integration into society on the aesthetic sense. Camp is a solvent of morality. It neutralizes moral indignation, sponsors playfulness." Clearly, camp, as Sontag describes it (i.e., disengaged, depoliticized—or at least apolitical), would be hard-pressed to sufficiently address the list of critical lesbian concerns cited above by Harmony Hammond, concerns that apply equally to gay men. While playfulness remains a strong current within gay and lesbian art, it is generally as an adjunct to, rather than as a "solvent" for, a reconstituted morality and progressive political agenda.

In this exhibition, a number of artistic areas emerge as substantially infused with the experience of gay men and lesbians. While perhaps not broad enough as phenomena to constitute "sensibilities" as such, these are, nevertheless, important areas for further exploration. For example, if we can speak of "gendered" abstraction in the work of Eva Hesse, Lynda Benglis or Jackson Pollock, can we speak of an abstraction of homoerotic experience in the work of Richmond Burton, John Cage or Louise Fishman? One notices, too, the extraordinary reinvigoration of agitprop styles and techniques in the work of Gran Fury, Boys with Arms Akimbo/Girls with Arms Akimbo, Dyke Action Machine! and Bureau. And there are numerous contemporary progeny of Marcel Duchamp's subversive gender-bending practices that are more conceptual than camp. If identifiable gay or lesbian aesthetic styles exist, they exist in multiplicity and in complex intersection with mainstream art practice. They are emanations of complex, fluid sociological constructs, never simply gay or lesbian. Just as manifestations of sexual desire and behavior are multifarious and mutable, so too are the reflections of those desires and behaviors in art.

By trying to work from objects and images—instead of exclusively from the sexual orientation of the makers—we arrived at one of our most important operating principles: to include both homosexual and non-homosexual artists, and to leave the sexual orientation of the artists unspecified in the exhibition. Some historical conditions (i.e., sexually-related social and legal oppression) pertain to the lives of self-identified homosexuals—whether closeted or not. But creative responses to those conditions are not limited to those directly affected. An ostensibly straight artist may identify strongly with any one of the numerous conditions—sexual or otherwise—central to the experience of gay men or lesbians. He or she may create a work of art that contributes to the dialogue of both the gay and lesbian communities and of the culture as a whole. Drag, for example, is situated primarily within the experience of gay men and lesbians because the culture at

General Idea, BABY MAKES 3, 1984—89

large identifies homosexuality with gender transgression. However, drag and its implications pervade the culture as a whole. Drag points toward the fact that any gender position is accomplished through role-playing and imitation. Works in this exhibition by straight artists such as Lynda Benglis and Robert Morris speak to this issue as cogently as the work of any gay man or lesbian. If there are such things that can be called gay or lesbian sensibilities—aesthetic or otherwise—these are highly amorphous phenomena within our culture and are not attached exclusively to people who have sex with people of the same sex.

While developing a broad social and historical framework, we also sought to acknowledge the initial inspiration for the exhibition— that is, the contemporary dynamism in communities of younger gay and lesbian artists. Ironically, within these communities, homosexuality—as a category of identity—seems to be posed increasingly more as a question than as a fact. For many artists in their twenties and early thirties—at least in those urban areas such as San Francisco, Los Angeles and New York—the very definitions of sexual identity are in flux. The category of "queer" is rapidly replacing "gay" or "lesbian" as the defining term for both men and women of this younger generation. Queerness—as opposed to gayness or lesbianism—or, for that matter, straightness—is becoming a term that subverts or confuses group identification rather than fostering it. Queer identity is spontaneous, mutable and inherently political. Much more than the terms "gay" and "lesbian," "queer" signals from the outset a way of life in which sexual freedom and gender transgression are but component parts. So, while the present moment seems to mark a historic watershed for gay and lesbian art, this extraordinary creativity may be happening not because of a solidifying of gay and lesbian identity, but precisely because of a crisis in that identity.

Some may argue that the sexual orientation of artists is irrelevant to art itself. I believe that art can and should at times be presented and experienced as an intimation—if not assertion—of universal experience. But such an approach need not rule out other interpretive strategies. A strong work of art is readable on a variety of levels, as a subject of specific historical, political or cultural interest, *and* as an expression of emotion or transcendent beauty. Recent debates pitting these approaches against each other—with antagonistic charges of Formalist Aestheticism versus Political Correctness—are divisive, unproductive and unimaginative.

As "In a Different Light" makes clear, the resonance of gay and lesbian experience in twentieth-century American culture has been profound in countless ways. At the same

time, it seems that the work of the younger generation of artists is telling us that categories of sexual identity are rapidly changing. Now may be the right time to reflect on our collective history while we still have one foot planted in gay, lesbian and straight experience and the other stepping into a new world whose definitions—and pleasures—are, as yet, unknown.

IN THE SUMMER OF 2001, I WAS DRIVING AROUND THE COUNTRY, LOOKING FOR art for the upcoming Whitney Biennial, and keeping a journal as I went. Here's what I wrote the day after visiting Fort Thunder, a sprawling artists' loft in a warehouse on the west side of Providence: "I walked around in a stupefied, ecstatic trance. The place is a dream: generous, creative, crazy in all the best ways. They are living an ideal without articulating it as a dogma, without marketing it, without theorizing it, just living it and dwelling in the amazing results." Even so, I had only the vaguest idea of what I was looking at, unaware as yet of the huge impact that the residents of Fort Thunder had already made, especially in the fields of comics and music. I knew nothing of the incredibly rich

Brian Chippendale, UNTITLED, c. 2000

national underground art culture centered not in Chelsea, New York's fashionable district, but in Olneyville—the derelict neighborhood in which Fort Thunder was based. I felt like I had stepped through a mirror into a parallel universe in which art was more likely to be given away than sold, in which extraordinary talent was combined with an absence of self-promotion and ego, and in which a distinctive, original and timely aesthetic had emerged. Fort Thunder was ten thousand square feet of trash-collaged living space governed by a single rule: you are free to make noise at any hour of the day or night. It was an insane storm of artistry with cacophonous sounds emanating from the mixing room, twisted and obscure posters filling the walls of the screenprint shop, comic-covered rooms and corri-

Fort Thunder print studio c. 2000, Photo by Brian Chippendale

dors, tangled mounds of tricked-out beater bicycles, odd knit costumes, an interactive "mask museum," and ten bedrooms, each of which was an installation artwork in its own right.

Among those who have heard of it, most know of Fort Thunder through the comics

or the music that were produced there. The now legendary Providence sound was nurtured at the Fort in countless shows, including—besides Fort Thunder-based bands Mindflayer, Lightning Bolt, and Forcefield—dozens of extraordinary groups such as Black Dice, Arab on Radar, Olneyville Sound System, Pleasurehorse, and 25 Suaves, to name a few. Most of the Fort Thunder residents who played in bands also drew comics. Although each artist developed a unique visual style, there is a distinctive Fort Thunder aesthetic that typically involved marks and images of unusual density, a suggestion of narrative with monster-like protagonists, innovative manipulation of the sequential panel form and a willingness to devote long hours to labor-intensive processes, such as multi-color silk-screening. Many critics have alluded to the distinctively innocent yet knowing style of drawing common to the Fort artists. "Picasso said he wanted to draw like a kid," observed Chris Lanier. "The Thunder folks want to draw like a special ed kid who's fielding transmissions from planet Gxxylplzz on his braces." Among the more ephemeral, but no less remarkable, material produced at the Fort, was the astonishing body of

prints that were made at one time or another by just about every resident. The prints were usually made to advertise music shows—as well as the Fort's peculiar tradition of costumed wrestling matches—but were also put to other purposes, such as covering the walls of the Fort's many rooms and labyrinthine corridors.

Brian Chippendale riding a Pete Fuller bike, c. 2000,
Photo by Dave Fischer

While the atmosphere of the Fort has been described by some residents as "competitive," there was nevertheless a productive spirit of collaboration—a sense of openness and engagement that extended to the way Fort Thunder existed in the fabric of the city itself. Although the Fort was filled with artwork, electronic equipment, printing presses, musical instruments and all the residents' personal possessions, once the lock broke, it was never fixed. Rather than losing everything to theft, the Fort began to attract remarkable donations.

Pete Fuller's bikes, c. 2000, Photo by Dave Fischer

Brian Chippendale, MAGGOTS (details), c. 2000

Old bikes, especially, flooded the place and were transformed by Pete Fuller into a host of peculiar, yet still rideable forms. Fort Thunder spewed forth creative work of all kinds at every hour of the day and night: there hadn't been a collection of such remarkably gifted artists working in tandem since the legendary Black Mountain College brought together under one roof the likes of Robert Rauschenberg, John Cage, Jasper Johns, Cy Twombly and Ray Johnson.

At first, the sheer number of residents, as well as their predilection to adopt pseudonyms and don costumes, made it difficult for me to discern individual talents within the maelstrom of Fort Thunder's creativity. Only recently have I begun to recognize and appreciate the individual accomplishments of the Fort's various residents and associates. Brian Chippendale, who is best known for his role as the drummer in the bands Mindflayer (with Mat Brinkman) and Lightning Bolt (with Brian Gibson), deserves to be celebrated too for his moody, rough-hewn and densely composed comics. Chippendale's narrative drawings covered the walls of Fort Thunder in literally thousands of tiny panels,

Forcefield in Concert, c. 2000, Photo by Brian Oakley

and were recently made available in a book titled *Maggots*. His comics, writes Tom Spurgeon, "burn with the energy of a five-year-old running around the yard with his pants off." Mat Brinkman, another of Fort Thunder's guiding spirits, creates amazing sound effects by, according to Mindflayer's website, "torturing analog devices until they die." His affection for noise—loud noise—underlies the sound of the Fort Thunder-based band Forcefield. Brinkman, like many Fort Thunderites, is both a musician and a visual artist. His comics typically feature the trials and tribulations of various monster-like creatures, and have been collected recently under the title *Teratoid Heights*, which was blurbed by his publisher Tom Devlin of Highwater books as "J. R. R. Tolkein-style adventure, videogame-inspired syncopation, and an endless barrage of cable-television nature films—all filtered through the reddened eyes of a marijuana-addled teenager." Jim Drain is a master of knitting, creating fantastical shrouds that have helped to transform the members of Forcefield from their earthly selves to their space-alien identities: Meerck Puffy, Patootie Lobe, Gorgon Radeo and LeGeef. He, too, creates distinctive comics that have been published along with Chippendale's, Brinkman's and others' in Fort Thunder's tabloid-format newspaper, *Paper Rodeo*. Ara Peterson, a member of Forcefield, though he never lived at the Fort, works in a variety of media, including sculpture, drawing and prints. His mind-bending, abstract videos borrow equally from cheesy sci-fi effects and the history of

Fort Thunder Interior c. 2000, Photo by Hisham Bharoocha

avant-garde film. In addition to their individual work, Peterson and Drain are pursuing ongoing collaborations on large-scale sculptures and installations. Leif Goldberg is characteristically multi-talented, performing with Forcefield as well as working as a printmaker, puppeteer, animator and editor (with Mat Brinkman) of *Paper Rodeo*. He is especially known for his ecologically themed comics and dizzyingly complex, exceptionally colorful screen-prints. Peter Fuller was the magician of bicycle transformation. There are many other artists, such as Paul Lyons, Brian Ralph, Rob Coggeshal, Andy Estep, Freddy Jones, Eric Talley, Erin Rosenthal, Joel Kyak, Shawn Greenlee, Maki Hanada and Raphael Lyon who lived at or passed through the Fort, whose individual work contributed to the unique culture of the place. Because of the ephemeral nature of much of what was made, only those who were lucky enough to visit can really appreciate the full scope of Fort Thunder's art revolution: it was the most profound you-had-to-be-there of our time.

Fort Thunder began in 1995 when Brian Chippendale and Mat Brinkman selected a floor of a recently vacated mill building as a site for booking shows. To save money, they decided to live there as well. The community that came to occupy and frequent the space, however, had begun to coalesce even before the space was found. In the mid-1990s, Providence had a lively scene of skaters, comic artists and musicians, many of whom were students at or dropouts from the Rhode Island School of Design. Collective artistic activity and spontaneous performance were common. One group, for example, consisted of RISD students who occasionally pushed shopping carts filled with accumulated trash to one of Providence's main shopping streets and then played music amid the piles of junk. Several bands producing the now distinctive Providence sound existed before Fort

Thunder opened. Among the most important of these were Dropdead, Six Finger Satellite, and Thee Hydrogen Terrors, which, as Jim Drain recalls, began with "local Rhode Island college kids that started hanging with RISD and Brown [University] kids—when that happened the feeling of here/'home' happened." A key event in the emergence of the Fort Thunder community occurred on May Day 1993. On that day, Brian Chippendale and Mat Brinkman, among others, organized a large party in the abandoned railroad tunnels that run beneath the east side of Providence. Less a celebration of working-class struggle than

Fort Thunder Interior c. 2000, Photo by Hisham Bharoocha

a rite marking the pagan proto-Halloween festival known as Beltane, the party involved dozens of fiery torches spread throughout the darkened tunnel, copious drumming and outrageous costumes. Unfortunately, the event, which was attended by several hundred people, was raided by the police, who used tear gas and pepper spray to subdue and disperse the crowd. CNN reported on the event, calling it evidence of a satanic cult.

Far from satanic, the Fort Thunder scene was imbued with an almost childlike innocence. Perhaps the most profound single influence on their work was Gary Panter's sets for the ebullient TV series *Pee Wee's Playhouse*. The darkness and edginess of some of the work, whether in comics, music, video, or in the occasionally violent wrestling shows, expressed feelings that were hardly occult but rather emerged from the familiar fears of any conscious person trying to make his or her way in our time of environmental destruction, social upheaval and nascent fascism. Their work was rarely directly political, but rather used archetypal themes to express allegorically the underlying tensions of our times. They borrowed heavily from fantasy literature, science-fiction TV and film, and

Fort Thunder Interior c. 2000, Photo by Hisham Bharoocha

role-playing games like Dungeons and Dragons. In contrast to many other artists working at the same time, for whom the challenge was to create a digital, virtual reality, much of the work made at Fort Thunder was an attempt to make a real reality of stories, images and objects that had only existed virtually before.

Fort Thunder was a powerful community but also a fragile one. As a curator from a major New York museum, I represented one of the forces that had the capacity to bring their dream to an end. Perhaps it was nothing more than their normal laconic-ness, but Mat, Jim and Leif seemed strangely quiet when they first met me on neutral ground at a nearby coffeeshop. I came bearing the promise of fame and fortune, but also an intimation of doom. How could the delicate ecology of Fort Thunder—based as it was on qualities utterly antithetical to the New York art world—survive transplantation to Madison Avenue? So it was with some trepidation that I ultimately offered these three Fort Thunder residents along with Ara Peterson, who together comprised the band Forcefield, a place in the 2002 Biennial. But it was my job to present the best art being made in the United States and, in that sense, including their work was one of the easiest selections I had to make.

Although Forcefield was already widely known to a community outside of the museum's usual audience, when they appeared in the Biennial, they suddenly became known to the mainstream. To many museum visitors, their Biennial installation, *Third Annual Roggabogga*, may have seemed like something of an anomaly. Most people had never seen anything like this before. What were these strange creatures, adorned with day-glo fur, sequins and flashing lights? The film component looked a bit like other experimental films, but what was it doing projected onto a wall covered in psychedelic orange wallpaper? And

that loud noise—what's that about? Yet, to the degree that this work, and much of the other work by the Fort Thunder artists, grew out of an interest in comics, science fiction, computer games, rock shows and, to an extent, skater culture, *Third Annual Roggabogga* resonated with numerous other works in the Biennial, including Chris Johanson's comic-inspired stairwell installation, Trenton Doyle Hancock's cartoony paintings of a self-invented universe, the late Margaret Kilgallen's hobo-skater-tagger environment, Christian Marclay's surrealistic band instruments, Destroy All Monsters Collective's billboards celebrating Detroit music and kiddie TV show history, Ari Marcopolous's offhand photographs and videos of international snowboarders, and Chris Ware's dense comic drawings. All of these artists found their primary influences less in the history of art than in a range of vernacular cultures, drawing on aspects of musical and visual practices from rock shows, graffiti and video games to comic-book superheroes and children's art, which are not much embraced by the mainstream art world.

As it turned out, the Biennial did mark the end of Forcefield. The stresses of engaging with an institution on the scale of the Whitney, along with disagreements on the next steps to take, led to the disbanding of the group. Brinkman and Goldberg had serious reservations about participating in the New York art world, and had no interest in producing work for gallery shows or selling their work in a conventional art market. Drain and Peterson enjoyed the larger audiences and felt there would be opportunities for growth if they accepted the challenges of fitting their distinctive work practices into the more conventional framework of commercial gallery exhibitions. Another factor contributing to the demise of Forcefield was the end of Fort Thunder itself. The old brick mill was sold to a developer who evicted the residents in early 2002—during the run of the Biennial—in order to begin demolition. In place of the sprawling old industrial complex that had once housed the most creative ten thousand square feet in America, the developer built a one-story retail mall called Eagle Square.

Providence meanwhile has spawned a number of other vital art collectives, including the Dirt Palace and Hive Archive, yet the dynamic culture that once sustained Fort Thunder, based as it was on exceptionally cheap rent, vast areas of essentially unregulated live-work space, and a comfortable distance from the New York art world, is probably gone forever. One wonders what will become of the dozens of profoundly gifted artists who were nurtured by that scene. Some will probably stay in Providence, developing their work in a less communal form. Others will migrate to even more remote towns and cities, gen-

erating new communities and practices. Some will certainly become stars of the mainstream art world, showing and selling their work in New York City's leading galleries. Fame and fortune need not mean the end of their freewheeling creativity. Every now and then, America makes room for something odd, and the artists of Fort Thunder may yet have their turn.

MUCH IS BEING MADE LATELY OF THE FBI'S PHONE CALL TO THE WHITNEY MUSEUM in the immediate aftermath of the 9/11 attacks, requesting access to Mark Lombardi's drawing *BCCI, ICIC & FAB*. This piece, the last work the artist made before he was found dead in his studio, represents the tangled web of power and influence that comprised the largest banking scandal in history. The names of Osama bin Laden and George H. W. Bush, among many other high- and low-profile world figures, are connected by a network of delicate, yet potently insinuating, pencil lines. The FBI agent who called was informed that the work was on view in the museum's galleries, where he was welcome to see it during regular museum hours. A visit to the current Mark Lombardi exhibition at the Drawing Center by an affiliate of the Homeland Security Agency has also raised eyebrows in the art world.

The typical response to these episodes has been one of startled indignation. We don't want Big Brother snooping around our museums, galleries and studios. Yet, wafting about these protestations is a hint of relief and even pride. Attention from the Feds accomplishes, for some, what so many of us have had trouble doing. It proves that art really matters . . . even to national security! Surrounded by constant reminders of our vulnerability, some may feel, albeit unconsciously, the need for art to do its part and so imagine that Lombardi has arrived just in time to secure the place of the fine arts in the emerging national paradigm of surveillance, paranoia and control. Unfortunately, or perhaps fortunately, the claims being made for Lombardi's relevance to the war on terror are rather overblown. No one knows if the FBI ever made it to the Whitney, and the Homeland Security guy was not on active duty. In fact, Lombardi's drawings don't reveal that much. According to his own iconographic code, a line with an arrow, for example, simply signifies "influence." So, a series of arrows leading across the *BCCI, ICIC & FAB* drawing from Bush to bin Laden does not necessarily mean that the two were in cahoots, as conspiracy theorists might wish to deduce.

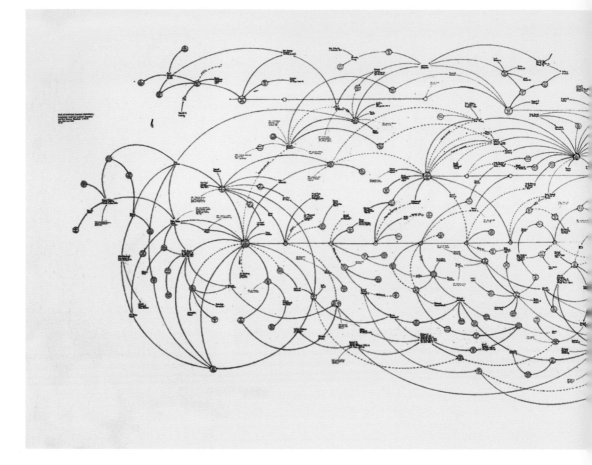

What Lombardi's works tell us is not the specifics of the connections between people, but simply that such connections exist. His drawings play across the surface of scandal and intrigue. This is not the sort of thing America's spies really need. Indeed, as far as tools for unraveling the networks of evil are concerned, they may already have the biggest and best at hand. Under the guidance of John Poindexter, of Watergate fame, the Defense Department has developed something called the Total Information Awareness program, a vast computerized database which, according to the official TIA website, utilizes "topsight"—a term coined by tech guru David Gelernter—to enable users "to see the whole thing." What is the "whole thing"? It is the same territory explored by Lombardi, the network of individuals, organizations, deals, transfers and transactions that constitute the de facto architecture of global power. Unlike Lombardi's beautiful but superficial diagrams,

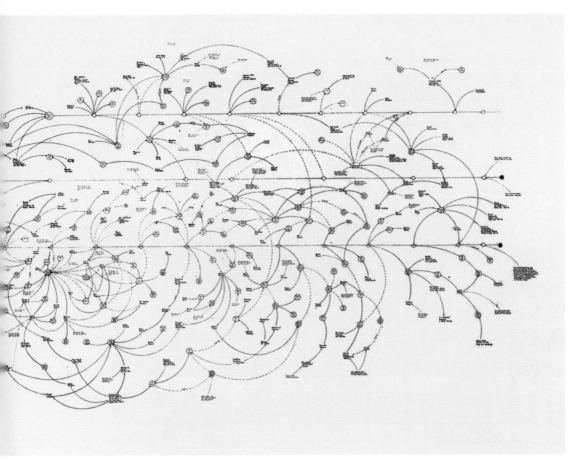

Mark Lombardi, BCCI, ICIC & FAB, 1996–2000

TIA goes wide and deep, providing "big picture" scenarios while simultaneously zeroing in on individual players and their possible motives in the emerging global terror drama.

Lombardi's drawings lack the specificity and attention to pattern needed to be useful as true investigative tools. On the contrary, it is in their very aimlessness, their sprawling attention to surface incident, that the works' purpose unfolds. In a recent article published by Clear Cut Press, the Office for Soft Architecture, based in Vancouver, explored the Pacific Northwest's invasive alien plant species, the Himalayan blackberry (*Rubus armeniacus*) as a figure by which to understand the attraction of surface as opposed to deep structure. "The limitless modification of the skin is different from modernization," they write. "Surface morphologies, as *Rubus* shows, include decay, blanketing and smothering, dissolution and penetration, and pendulous swagging and draping as well as proliferative

growth, all in contexts of environmental disturbance and contingency rather than fanta-
sized balance." They go on to say, apropos of architecture itself, "Superficies, whether wo-
ven, pigmented, glazed, plastered, or carved, receive and are formed from contingent
gesture. Skins express gorgeous corporeal transience. Ornament is the decoration of mor-
tality." In Mark Lombardi's work, we have just such an expression of the smothering
abundance of ornamental information.

In cyberspace, the architectural parallel to Lombardi's work is not to be found in the
utilitarian, "drill-down" salt mine of the Defense Department's TIA, but in the burgeoning
blackberry bush tangle of Friendster.com. For the one or two of you who still don't know,
Friendster is an online network in which members can connect to friends, as well as

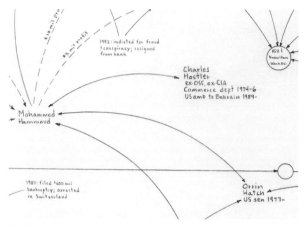

Mark Lombardi, BCCI, ICIC & FAB (detail), 1996–2000

to friends' friends, friends' friends'
friends, and so on. As a result of
having thirty-two friends in my im-
mediate network, I am automati-
cally linked to a larger network of
441,710 individuals. I can search
this database by gender, age, locale
and interest. Unlike some more
purposeful sites, such as the busi-
ness network LinkedIn, or any of
the many cruising spots online,
Friendster is notably open-ended.

In addition to identifying oneself as looking for a "friend" or a "serious relationship," one
can also present oneself as "only here to help." It is in part this indirectness which sug-
gests a parallel to Lombardi's indeterminate fields of "influence."

When you can count nearly half a million people as your friends, your social circle
ceases to have a recognizable shape. The absurdity of scale is another parallel between
Friendster and Lombardi's drawings, especially the monumental works like *BCCI, ICIC &
FAB*. A financial scandal this large is no longer a scandal, strictly speaking; it's a way of
life. Unlike TIA, Friendster never resolves into a gestalt, never exposes an "underlying ra-
tionale." Rather than betraying an a priori, deep structure, it expands rhizomatically into a
contingent structure of its own, based solely on temperament and loose affiliation. Simi-
larly, Lombardi's drawings are shapeless, infinitely extensive webs of innuendo.

Curiously, in the last year of his life, Lombardi created a series of works that suggests

John Currin, THE PINK TREE, 1999

he was leaning toward a more Platonic conception of the networks that his research had uncovered. In these pieces, the pattern of lines resolves clearly into perfect or near-perfect spheres. By indicating the existence of a unifying gestalt, Lombardi edges toward the conception of networks articulated by the philosopher and theologian Teilhard de Chardin. Credited by some with conceiving the Internet *avant la lettre*, Teilhard postulated a kind of global consciousness that he dubbed the Noosphere. Recently, followers of his theories have launched a worldwide effort, called the "Global Consciousness Project," which draws on the Internet's extraordinary capability for synthesizing vast amounts of information drawn from remote locations. Computers worldwide feed into a central database information concerning human behavior on massive scales (i.e., strikes and armed conflicts) and attempt to measure a cause and effect relation—energetically speaking—among them. Their efforts are intended precisely to discern the kind of background pattern revealed in so many of Lombardi's final works.

For some, Mark Lombardi is the natural inheritor of Hans Haacke's distinguished mantle. Haacke, who appeared with me recently on a Drawing Center panel concerning Lombardi's work, pioneered in the late 1960s a no-frills approach to using art as a means to analyze the complex, money-infused relationships among individuals, corporations and institutions. These artists have much in common, to be sure, and yet something in Lombardi's work exceeds Haacke's straightforward approach. Curiously, it was during the past several weeks, while installing the Whitney's mid-career survey of John Currin's idiosyncratic figurative painting, that I began to sense that here was perhaps a more apt comparison. Currin, like Lombardi, enjoys telling us both more and less than we need to know. Is it possible that Lombardi's drawings really have more to do with the Mannerist excesses and creepy lacunae of Currin's paintings than they do with the methodogical investigations of Haacke to which they are often compared? I suspect that Lombardi's works fall someplace in between, a place that is difficult to imagine, but which, in our complicated times, nonetheless rings true.

" . . . in these times of dreary crisis, what is the point of emphasizing the horror of being?"
—*Julia Kristeva*, Powers of Horror

IF THE GOTHIC NOVEL AND THE HORROR FILM HAD A CORRESPONDING GENRE IN the visual arts, Luc Tuymans would be its newest avatar. Gothic horror resonates in the graphic art and painting of Piranesi, Goya, Füssli and Bresdin; in our time, artists as diverse as Salvador Dalí, Meret Oppenheim, Bruce Connor and Cindy Sherman have inspired fear, loathing and revulsion. Yet their works do not comprise a horror genre per se; rather, it is almost a defining trait of this temperament among artists that their products appear sui generis. Hence, there can be no equivalent in visual arts criticism to Eve Kosofsky Sedgwick's literary analysis, *The Coherence of Gothic Conventions*, or Stephen King's classification of horror literature and film, *Danse Macabre*. When Tuymans talks about his influences and affinities, it is primarily to literature and film that he refers: the films of Murnau, Franju or Polanski, or his current fascination with the writings of Thomas Pynchon. In exploring the role of horror in Tuymans's art, it is helpful to do so while glancing sideways in these directions.

Tuymans's art may initially appear bland and innocuous; even those pieces clearly related to Nazism possess a subdued, weary affect. The more time you spend with his art, though, the more unnerving it becomes. Something in it persists, subliminally, with a pulse like a watch wrapped in cotton, as Poe described the "tell-tale heart." Like Polanski's *Knife in the Water*, in which primal rage flickers at deadly voltage just beneath the surface, Tuymans's best works veer between innocence and panic, tightly coiled yet never sprung. Restraint itself becomes almost unbearable: why such repression? What enormous force is being concealed? Even as we are being protected from the worst, the magnitude of that dark power is revealed.

In *Danse Macabre*, Stephen King proposes for horror three categories of effect. Of these, the lowest, in his estimation, is "Revulsion," which is produced simply by gruesome imagery, like the chest-bursting scene in *Alien*. There may be one or two examples of this in Tuymans's oeuvre: perhaps the paintings *Eyes Without a Face* (the title and subject of which are borrowed from the filmmaker Franju) and *Bloodstains*—though, really, both are too mild to qualify. Much of Cindy Sherman's grisly photography, on the other hand, fits squarely into this category. The middle level, which King calls "Horror," is distinguished

Luc Tuymans, BLOODSTAINS, 1993

from "Revulsion" by leav-ing more to the imagination while still pre-senting physical evidence of some-thing amiss. Tuymans's painting *Superstition* achieves this highly charged balance. According to King, the "finest" emotion of the three cat-egories is "Terror," in which nothing is shown to be wrong, but an atmo-sphere of fear is created that is im-palpable and omnipresent. Look at *Rear Mirror*—terror is what Tuy-mans does best.

The kind of terror King de-scribes and Tuymans evokes so po-tently often goes by other names: evil, the abject, the unspeakable. "The essence of evil," social anthro-pologist Alan Macfarlane writes, ". . . is shadowy, mysterious covert, hidden. . . it is aggressively, insidiously undermining, the worm in the bud. Things are not what they seem: the smiling face conceals hatred; the friendly gesture leads to downfall. The same person is both a neighbor and possibly a member of a secret, subversive organization." Julia Kristeva, meanwhile, calls it "the ab-ject": ". . . a massive and sudden emergence of uncanniness, which, familiar as it might have been in an opaque and forgotten life, now harries me as radically separate, loath-some. Not me. Not that. But not nothing, either. A 'something' that I do not recognize as a thing. A weight of meaninglessness, about which there is nothing insignificant, and

Luc Tuymans, SUPERSTITION, 1994

which crushes me. On the edge of non-existence, hallucination, of a reality that, if I acknowledge it, annihilates me."

What underlies all of these conceptions is a raging sense of paranoia. When threats are explicit, paranoia is superfluous; but in the realm of the implicit and the possible, paranoiacs are right at home. This is where we find Tuymans at work. It's not surprising to learn that Luc Tuymans the Terrorist is reading Thomas Pynchon the Paranoiac. They are stylistic twins, equally adept at the kind of insidious gestures that send shivers down the spine. Both exploit quirky emphases that load their works with ominous significance; both encourage confusion between interior and exterior spaces; both cultivate a sense of moral ambiguity. There is also in Pynchon's style a quality of indirectness and elliptical meaning that echoes the frequently obscure or indistinct description of subjects in Tuymans's art.

Luc Tuymans, REAR MIRROR, 1986

Pynchon's *Gravity's Rainbow* is a labyrinthine novel that takes place during the immediate aftermath of World War Two as the nascent Cold War powers jockey for position amid the ruins of Europe. In the following passage, the hero, Slothrop, has just heard that Roosevelt is dead:

"They said it was a stroke," Saure sez. His voice is arriving from some quite peculiar direction, let us say from directly underneath, as the wide necropolis begins now to draw inward, to neck down and stretch out into a Corridor, once known to Slothrop, though not by name, a deformation of space that lurks inside his life, latent as a hereditary disease. A band of doctors in white masks that cover everything but the eyes, move in step down the passage to where Roosevelt is lying. They carry shiny, black kits. Metal rings inside the black leather, rings as if to speak, as if a ventriloquist were playing a trick, help-me-out-of-here. . . . Whoever it was, posing in the black cape at Yalta with the other

leaders, conveyed beautifully the sense of Death's wings, rich, soft and black as the winter cape, prepared a nation of starers for the passing of Roosevelt, a being They assembled, a being They would dismantle. . . .

Eve Kosofsky Sedgwick identified such indirectness—she calls it "the unspeakable"—as one of the central conventions of Gothic literature: "The story does get through, but in a muffled form, with a distorted time sense, and accompanied by a kind of despair about any direct use of language." Such a characterization clearly applies to Tuymans, whose work is both self-consciously anachronistic and sketchy—at times almost to the point of disappearance. The total lack of affect in Tuymans's images of Nazi officers, as well as in his portraits of terminally ill patients, echoes the passive and rather despairing sentiments expressed in Thomas De Quincey's Gothic classic, *Confessions of an Opium Eater*: "To fight up against the wearying siege of an abiding sickness imposes a fiery combat. I attempt no description of this combat, knowing the unintelligibility and repulsiveness of all attempts to communicate the incommunicable."

Again, in light of Tuymans's work, Kristeva's thoughts on "the abject" echo Sedgwick's Gothic "unspeakable":

> . . . he is not mad, he for whom the abject exists. Out of the daze that has petrified him before the untouchable, impossible, absent body of the mother, a daze that has cut off his impulses from their objects, that is, from their representations, out of such a daze he causes, along with loathing, one word to crop up—fear. The phobic has no other object but the abject. But that word, "fear"—a fluid haze, an elusive clamminess—no sooner has it cropped up than it shades off like a mirage and permeates all words of the language with nonexistence, with a hallucinatory ghostly glimmer. Thus, fear having been bracketed, discourse will seem tenable only if it ceaselessly confronts that otherness, a burden repellent and repelled, a deep well of memory that is unapproachable and intimate: the abject.

A number of other ostensibly Gothic conventions turn up in Pynchon's as well as Tuymans's works. For example, Pynchon's necropolis, which expands inexplicably and bizarrely downward and which holds the marginally sentient Roosevelt, echoes Sedgwick's theme of live burial as well as that of the paradoxically expansive prison. As in Piranesi's

Luc Tuymans, ANTICHAMBRE (BLAUWE KAMER), 1985

Luc Tuymans, THE ARENA, 1978

Carceri d'invenzione, it is the viewer himself who is buried in Tuymans's exitless spaces. Tuymans, too, achieves a sense of suffocating yet limitless space: "It is a space that never ends," he explains, "a space that goes beyond the image itself." Sedgwick writes, "A prison which has neither inside nor outside is self-evidently one from which there is no escape . . . but it is also one to which there is no access. The particular claustrophobia of [Piranesi's] vision is that it rejects the viewer even as it lures her in and exerts its weight on her."

Pynchon's "white masks" and "black cape" recall the Gothic veil, an image that both marks the threshold between inside and outside, and in its insubstantiality signifies the very vulnerability of that demarcation. For Sedgwick, the veil's imprecise bordering alludes to the in-stability of identity and constant shifting between self and other in the Gothic tradition. The ambiguity of the veil is frequently exploited by Tuymans, not only in his frequent close-up depictions of human skin and fabric where peculiarities of scale accentuate the veil's destabilizing effects, but also in his treatment of the artworks' surface. His works characteristically appear to be seen through some kind of thin haze or milky cloud. In some cases, such as *The Arena*, this veil becomes literalized with the use of an overlay of semi-transparent material.

Stephen King asserts that the tropes of the horror genre arise from the specific unconscious fears of an age. Indeed, it is tempting to see Tuymans as a kind of history painter whose art reflects our own era of ultra-nationalism and resurgent Fascism. Our recent history has also been a period of astonishingly sordid events and revelations; not long ago, for example, the mysterious deaths of two young girls led to the exposure of a child sex-slave ring extending into the very highest levels of the Belgian police force and government. There are echoes of such contemporary social traumas in Tuymans's work, although these echoes may be faint, obscured or couched in allegory. In the most literal

sense, we might see his images of the Third Reich as signaling not so much a retrospective view as a masked expression of current events. As such, the muted, bloodless appearance of these images is not a result of the "unrepresentability" of their nominal subject, the Holocaust—after all, Tuymans approaches other subjects, such as Belgian nationalism and clinical pathology, in an equally understated fashion. Rather, their muteness betrays a deep anxiety about the very location of the feeling subject and hints at a bifurcation of the artist's existential and social conditions. That is to say, the artist appeals to a peculiar feature of the modern psyche: a waning of superstitious thinking mixed with a lingering nostalgia for the viscerality of evil. These two tendencies are incommensurable, according to Macfarlane: since the rise of industrial capitalism, evil has "been almost abolished." In earlier times, writes Macfarlane "when havoc [fell] out of clear sky and [struck] down an individual or a society, there [was] evil at work." Now, our culture seems to be reaching ever more extreme conditions of banality, so that even such grotesque incidents as the Bel-

gian child sex-slave scandal are soon absorbed and forgotten. Rationality has replaced superstition as the explanation for human actions. However bad things may seem, we now live in a world thoroughly permeated by Enlightenment logic and values. If evil still exists, it exists solely in the realm of nostalgia. This may explain why Tuymans's works—especially his drawings—are so distanced from the here and now: cracked, torn, ephemeral, they have the appearance of future artifacts. Because terror has been relegated to the past, the past—as such—has become fraught with ominousness. Thus, as exemplified in Tuymans's art, nostalgia itself has become the horror trope par excellence of our time.

Paul Delaroche, THE DEATH OF CARDINAL MAZARIN, 1830

The ineluctable, modern problem of evil's haunting presence in a desacralized universe is the crux of Tuymans's art. As such, it is interesting to compare his work to that of Paul Delaroche, the French painter of the *juste milieu*, whose works—created at the dawn of the modern age—bear more than a passing resemblance to Tuymans's. Delaroche's paintings, such as *The Death of Cardinal Mazarin, The Death of Queen Elizabeth I of England, The Children of Edward IV in the Tower* and *The Execution of Lady Jane Grey*, are bland renditions of ghastly subjects removed historically from the painter's time, yet bathed in a strangely nostalgic afterglow. The two artists' works share a quality of random composi-

tion and weary airlessness that derives from their conjoining of the modern social condition with an archaic spirit of evil. Like Tuymans, Delaroche lived in an era when rhetorical Liberalism flourished while powerful memories of recent catastrophe—for Tuymans, the Holocaust; for Delaroche, the revolutionary terror and Napoleon's totalitarian excesses— were undergoing a massive repression. Delaroche's diminutive *The Death of Cardinal Mazarin* is a very near cousin, if not a sibling, to Tuymans's *Gaskamer*; both evoke a simultaneously nauseating and vertiginous sense of "the spaciousness and vacuity of the imprisoning environment." Tuymans, like Delaroche, appeals to our nostalgia for terror only to smite us with us with a terror of nostalgia.

ART LIFE | Louise Bourgeois: Drawings

IN PREPARATION FOR AN EXHIBITION, I PAID LOUISE BOURGEOIS A VISIT SHORTLY after her eighty-third birthday. Bourgeois is reluctant to explain her art and dreads admitting strangers to her home. Yet, the only things more troubling to her than her own explanations are the explanations of others. So, in a pinch, she'll let you in to tell you what she thinks.

Bourgeois lives in an unprepossessing row house in the Chelsea district of Manhattan, across the street from an old, square-steepled church. She comes to the door with an irrepressible smile and glinting eyes. Inside, it is dark and cool and somewhat decayed. There are no pleasantries; in fact, she disappears. I find my way to the living room; through the tall French windows and iron grates come the sounds of schoolchildren at play. With hesitation, we become acquainted while she sketches at a small drawing table in a corner of her cluttered living room. On each subsequent visit, she sits there again with an assortment of drawing tools at hand, as if armed against the tension of our meeting.

I intended to document the artist's observations concerning a large and diverse group of her drawings created over the past fifty years. I soon found, however, that the world of Bourgeois's art—in which human contact is fraught with trepidation, guilt and pain—is also the world of Bourgeois's daily life. Such interviews as these were a necessary evil of her life, and she railed openly against them. Often I felt barely tolerated; once she even summarily ushered me out of her home before the day's session had begun. My visits occasioned the dynamic so often represented in her art: an irresolvable tension between self-revelation and withdrawal. Although she takes great pleasure in their creation, for Bourgeois, making drawings is as necessary as locking the door each night.

There are some contradictions in Bourgeois's estimation of her own work. Drawings, she insists, are secondary to sculpture inasmuch as they lack the power of exorcism. And yet, for fifty years—with some dry spells in between—she has drawn precisely to find

Louise Bourgeois, UNTITLED, 1968

the daily, even momentary, strength to carry on. Drawings may not expel demons, but they certainly seem to hold them at bay. Bourgeois also insists that her work is primarily visual and that its effect does not depend on verbal explanation. Yet there is a remarkable way in which these works are woven into her personal history. The meeting of these images and her observations is neither art nor precisely art history, nor quite autobiography; it is something else, perhaps more rich than any of these disciplines on their own.

While dismissing verbal explanation of her work, Bourgeois took our words together with utmost seriousness. For our first few meetings, I had hoped simply to talk informally about her art, developing a personal rapport before the recorded interviews began. But she had little patience for such geniality and demanded to know why I wasn't taking notes. Bourgeois is a compulsive recorder of data: emotional data, visual data, personal historical data. She asks no less of those around her. Hers, finally, is clearly not art for art's sake; it is art in the service of comprehension.

Louise Bourgeois, UNTITLED, 1988

Louise Bourgeois, UNTITLED, 1987

Bourgeois appears to have embraced the modern world: studying geometry at the Sorbonne; forsaking in her early thirties France for America, the cultivated charms of Paris for the steely anonymity of New York; aligning herself on occasion with radical political causes—and traveling twice to Moscow to see for herself the progress of their Utopian dream; maintaining a passionate, if sometimes equivocal, relationship to the feminist movement; posing famously for Robert Mapplethorpe, provocatively embracing—or perhaps wielding—her voluptuously phallic sculpture *Filette*; and recording her own rap CD, which she proudly played for me on the day of our final interview.

Yet there is a tug backward, a tug as ominous as a knock from the inside of a tomb. The tug is on a thread that trails back into Bourgeois's childhood and infancy: back into the family workshop on the banks of the Bièvre, where Louise assisted at repairing ancient tapestries; back into the rock and soil of the impoverished valley of the Creuse, where her ancestors were lintel cutters and weavers; further back, even, to a time when a girl could

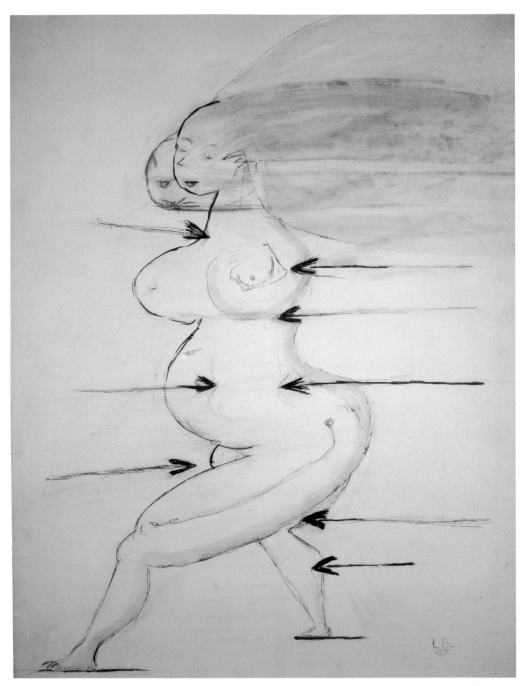

Louise Bourgeois, UNTITLED (ST. SEBASTIENNE), 1987

fly or sprout leaves to be free, when a fearsome mother might consume her children whole, when the geometry of the constellations and the passions of the gods were one and the same.

Bourgeois describes one of her recent drawings as expressing "an ideal state . . . a state of reason." The drawing is simply an oval divided neatly into harmonious, complementary halves. It is her favorite color, blue—the color of tranquility. Abstract, geometric and utopian, this drawing is the very emblem of the Modern. Another work from the same year, though, looks like something scratched into the wall of a cave. It depicts a running woman assaulted in front and behind by volleys of arrows. The drawing captures the woman—it is the artist herself, she tells us—in a moment of metamorphosis: one face shines with sweetness and light, the other is feline and brooding. For Bourgeois, Barbarism and Reason are not simply two of the Ages of Man, comfortably ensconced in the historical dialectic. Rather, they are fervid eruptions of the soul, eternally at odds. There is no reassuring progression in her work, only this powerful, recurring dichotomy.

Bourgeois insisted that we review her work in chronological order. Certainly, this method throws into greater relief her various, often overlapping thematic and stylistic periods. Yet Bourgeois's observations expose the complexity of such an approach. In many instances, an older work brought to mind ideas that were of interest to her in the present, but which had little relevance at the time of its creation. During the period of our interviews, she was especially involved with theories of hysteria, had recently read Bruno Bettelheim's study of autism, *The Empty Fortress*, and was intrigued by the practice of meditation, which she saw as a potential cure for the torment of her insomnia. Ideas drawn from these and other contemporary sources were occasionally projected retrospectively onto older works. Of her recent drawings, Bourgeois had the least to say, perhaps because their visual meaning was still congruent with her current frame of mind. They spoke, she felt, for themselves.

A photograph by Brassai taken in 1937 shows Bourgeois at the Académie de la Grande Chaumière in Paris, sculpting a copy of an archaic Greek bust. One year later she was in New York, living with her new American husband, the art historian Robert Goldwater. Enrolled in a course at the Art Students League, Bourgeois's work reflected the expressive neo-Cubism of the painter Vaclav Vytlacil and her other early teachers Fernand Léger and André Lhote. Gone were any vestiges of her classical training, and very soon Bourgeois was manifesting her own strongly idiosyncratic sensibility.

During the 1940s, Bourgeois's drawings were populated by a host of ethereal creatures, quizzical ink sketches of beings that alternately soared or descended—beneath waves or arid expanses of desolate land. There is little in them to suggest their expressive intent: the creatures' faces remain placid and impassive whether the subject—as she describes it—is the story of a happy family or a suicide. These drawings have a cartoonish quality, and, indeed, the images are often presented in sequence, as if awaiting the touch of animation. They have a quality that is truly, to use one of the artist's favorite phrases, "featherlike."

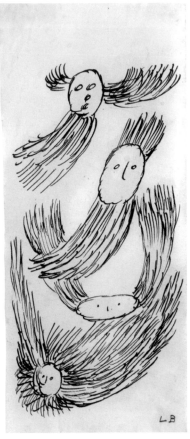

Throughout the 1940s, Bourgeois also produced a series of images inspired by the landscape of the Creuse region of central France, a terrain she remembers from her childhood as "deserted and sterile." In these drawings, the repetitive patterns of black ink lines suggest the striation of jagged mountains or the desiccated rills of waterless soil. These scenes are uncanny, however: where there should be absolute stillness, there is motion. Their patently inorganic forms seem oddly alive: they throb, they sigh, they move in queasy undulations. One is left with a vertiginous sensation of collapsing scale, as if what one had assumed to be a view of a mountain peak suddenly came into focus as the upsweeping strands of a recalcitrant cowlick.

Produced at the same time as these scenes of rock and earth, and sometimes indistinguishable from them, are drawings that capture with the same striated black ink lines the patterns of hanging and growing plants. Like the landscapes, these too can appear as hair: long, beautiful yet cumbersome tresses much like those Bourgeois herself wore as a young woman. Bizarre amalgams of plant, animal and machine appear in numerous drawings from the 1940s and 1950s. These ambiguous images are rife with allusions. The artist has identified the sources of some of the imagery: the roundabout swing her family

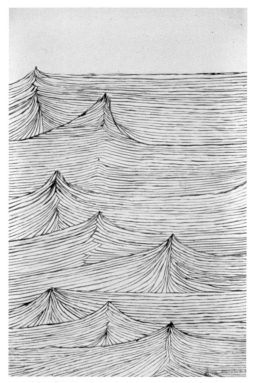
Louise Bourgeois, THROBBING PULSE, 1944

kept in the yard for the children's amusement, the hanging vegetables and grains they dried in the attic during the winter, the pop-up punching toy called a *ludion*, and Saint Sebastian cut through with arrows.

Yet Bourgeois lives in a world in which memory and metaphor collide. Images rarely remain politely just what they are; a tree, a children's swing, a knot of thread, a sheaf of hanging grain metamorphose into self, children, lovers, and various powers and frailties of the mind. The image of the house or lair garners much significance in her work, because it is in the house more than anywhere else that reality and imagination struggle for supremacy. And for Bourgeois, the house is not only the site of dreams and daydreams, shelter and comfort; it is the site of infidelity, treachery and abuse—it is the site of Family. Recently the spider has become a powerful metaphor in Bourgeois's work: the spider, a conventionally vile creature, rehabilitated and made queen of a harmonious home. Whether taut on her geometric web or tending eggs in the corner of a spacious abode, these spiders symbolize an imaginary familial well-being.

For Bourgeois, the central problem of life is to find a means of getting along with other people; the central problem of art, to express this challenge. The name she has given this problem is the "*toi et moi*," or "you and me." For her, the relationship of one person to another—though usually experienced as suffering—is all-important, and life has little value without it. She identifies the ideal human contact as a "perfect fifty-fifty"—that is to say, an equilibrium. Across styles and subjects, one finds the theme of *toi et moi* again and again in her work. Whenever one figure reaches toward another, whenever two abstract forms balance against each other in space, whenever such balance is broken—it is an expression of this essential drive toward human rapport.

In her life and in her art-making, Bourgeois is guided by Camus's existentialist

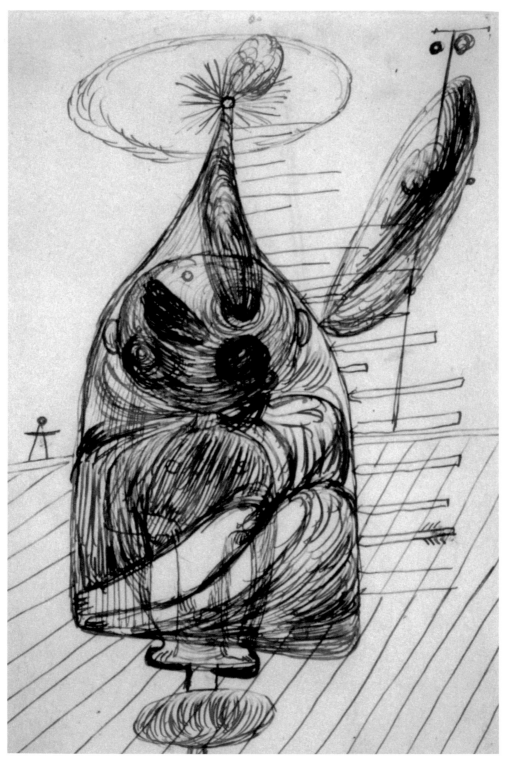

Louise Bourgeois, UNTITLED, 1946

creed: the only act more profound than Sisyphus's struggle against gravity is his surrender to it, his return down the slope after the stone has rolled.

I see that man going back down with a heavy yet measured step, toward the torment of which he will never know the end. That hour, like a breathing-space which returns as surely as his suffering, that is the hour of consciousness. At each of those moments when he leaves the heights and gradually sinks toward the lair of the gods, he is superior to his fate. He is stronger than his rock.

THERESA HAK KYUNG CHA'S ART STANDS OUT, EVEN AMONG THE WORK OF THE most accomplished and celebrated of her contemporaries, for its poetic depth, formal and material inventiveness, and theoretical rigor. During her short life—Cha was murdered in 1982 at the age of thirty-two—she created a remarkably coherent body of work in film, video, poetry, artists' books, slide projections, performance, drawings, mail art and sculpture. Her deceptively simple, sometimes even offhand, artworks grew out of Cha's broad understanding of world religions, history, political science, film and film theory, linguistics, psychoanalysis, communications theory, cognitive psychology and feminism. Yet, she subsumed every source and inspiration into a profound and idiosyncratic artistic expression based strongly on the incidents of her own life.

By far the most significant theme in her work is her family's exile from Korea in 1963 when Cha was twelve years old. While she occasionally addressed the personal and historical circumstances of this wrenching experience, Cha usually treated the theme symbolically, representing displacement through shifts and ruptures in the visual and linguistic forms of her work. In her video and film installation, *Exilée* (1980), Cha's exile from Korea is captured through the meticulous measurement of the physical and temporal distance to her lost homeland. As black-and-white images of clouds fade in and out on the video screen, Cha recites these incantatory lines:

> Backwards. from backwards from the back way back. to This. This
> phantom image/non-images
> almost non-images without images each ante-
> moment moment no more no more a moment
> a moment no duration no time. phantom no visible
> no name no duration no memory no reflection no echo

Theresa Hak Kyung Cha, EXILÉE, 1980

Any possibility of closing the gap of physical and temporal distance is washed away in a flood of abnegation.

The seeming impossibility of physical return is touched on, though even more abstractly, in an untitled video (c. 1974). This work consists of a sequence of words and short phrases that fade in and out against a white background. Three times in the video (indicated below with dashes), however, the transition between words is achieved with a slow camera pan to the right, thereby rupturing one's impression of these words as mutable images with a reminder of their physical, graphic actuality.

> ripples. gone. going. go again. gone. far. farther. far
> again. farther gone. going again. farther again.
> far. never. return. gone to return. going never—never to
> return. never. return to. go again. never. return to.
> far again—farther. gone. far gone never. never again far.
> never again—farther. return. return far. farther. again.
> return. gone never. going never. never go. never.

Rather than charting a clear path home, this work evokes a labyrinthine sensation of motion without origin or destination. The only place markers in this dizzying maze, the words themselves, are reduced, through their repetition, to virtually meaningless signs.

By invoking forms, motifs and themes borrowed from traditional Korean culture, Cha seems to have attempted to overcome her physical and cultural displacement, and create bridges to link her present to her past. Her work is rich with references to Korean dance, history, literature, politics, religion, language and mythology. However, rather than building a coherent picture of Korean identity, Cha's work reveals fracture upon fracture, destabilizing the relation of past and present, home and exile, being and non-being.

The single-channel video *Mouth to Mouth* (1975), for example, is an encounter with the Korean language at its most elementary level, beginning with a slow pan across the eight Korean vowel graphemes. This is followed by close-up shots of a mouth silently enunciating each vowel in the previously represented graphic sequence, alternating with passages of video static or "snow." The mouth itself is never precisely in view, always remaining partially obscured by, and periodically dissolving into, the swarming video-static effect. The sound of a babbling stream with occasional bird songs fades in and out with no

Theresa Hak Hyung Cha, MOUTH TO MOUTH, 1975

apparent correlation to the video imagery. The hypnotically gurgling water and the erasure performed by the video snow suggest a loss of language over time.

The Korean written alphabet was invented in 1443 A.D. by King Sejong, a linguist, who worked closely with a group of eight scholars to develop an alphabet more suited to convey the Korean phonemes than the complex Chinese characters previously used. Sejong's twenty-eight-letter alphabet, called *hunminjongum*, is distinguished, in part, by the fact that it was based on the articulatory phonetic theory. In articulatory phonetics, the shapes of the letters were modeled after the shape of the mouth and tongue in the act of pronouncing the sounds represented by the letters. Thus, while Cha's video questions the dependability of language as a cultural signifier by representing its mutability over time, she simultaneously rehearses the very logic of the Korean alphabet's creation. As in the untitled video previously discussed, *Mouth to Mouth* leaves the viewer in a state of suspension in which past and future, before and after, seem to lose all polarity.

In addition to evoking aspects of the Korean language, Cha turned her attention to the structures of Korean religious and social codes as a possible means for centering her displaced identity. Here, too, however, she was to find not a foundation of pure cultural origin but a fluid and highly opaque layering of past and present realities and hybridized cultural experiences. Confucianism, for example—which, besides Catholicism, is the major Korean religious institution—serves as the model for Cha's recurring invocation of filial connection. In Confucianism, the most sacred tie is not to a supernatural entity or entities but rather the bonds that exist among blood relatives. In the opening section of her book *Dictée* (1982), Cha writes:

> From A Far
> What nationality
> or what kindred and relation
> what blood relation
> what blood ties of blood
> what ancestry
> what race generation
> what house clan tribe stock strain
> what lineage extraction
> what breed sect gender denomination caste
> what stray ejection misplaced
> Tertium Quid neither one thing nor another

Tombe des nues de naturalized

what transplant to dispel upon

Dictée can be understood as Cha's attempt to recall her lost genealogy and to articulate it in words and images. Yet, speech itself appears to have been fractured through the trauma of exile. Again, from the opening section of *Dictée*:

> She mimics the speaking. That might resemble speech. (Anything at all.) Bared noise, groan, bits torn from words. Since she hesitates to measure the accuracy, she resorts to mimicking the gestures with the mouth. The entire lower lip would lift upwards then sink back to its original place. She would then gather both lips and protrude them in a pout taking in the breath that might utter something. (One thing. Just one.) But the breath falls away. With a slight tilting of her head backwards, she would gather the strength in her shoulders and remain in this position.

It is through a willful act of self-deception, of first becoming "other," that Cha regains her ability to speak:

> She allows others. In place of her. Admits others to make full. Make swarm. All barren cavities to make swollen. The others each occupying her. Tumorous layers, expel all excesses until in all cavities she is flesh.

Cha's loss of speech stems from her displacement, physically and culturally, from the Confucian chain of being, and the regaining of speech is inextricably connected to the discovery of a new set of filial relations. While Cha's mother, Hyung Soon Huo's narrative appears in *Dictée*, a host of other voices carry the reader far afield of familial blood ties: we meet the nine Greek muses, Joan of Arc, St. Thérèse of Lisieux, Carl Dreyer's Gertrude, the Korean nationalist hero Yu Guan Soon, and a Mrs. Laura Claxton. Cha still seeks her identity by charting her place within a constellation of lineage and relation; however, these social structures have become radically multicultural, and their signifiers—the myriad women who appear in the book—are not biologically related, but reflect what C. G. Jung would have called an archetype of the collective unconscious, drawn from the "ancestral heritage of the possibilities of representation."

Cha also links her own struggle to remember and to speak with the extraordinary

cultural oppression suffered in Korea during its forty years under Japanese rule. For centuries, Korea experienced routine invasions by both China and Japan. Following their victory in the Sino-Japanese War in 1895 and the Russo-Japanese War in 1905, Japan took full control of the Korean peninsula. At first, the Japanese installed a "protectorate government;" however, by 1910 they had moved toward full annexation. Japanese restrictions on the practice of Korean culture became increasingly restrictive, especially following the Independence Movement of March 1919, during which tens of thousands of Koreans marched in protest of Japanese rule. As described by historian Andrew C. Nahm, conditions under the Japanese verged on cultural genocide:

> [The Japanese] planned to assimilate the Koreans into Japanese culture and to construct a strong logistic base for Japan's continental expansion. In order to achieve these objectives, the Japanese inaugurated many programs: the use of the Korean language was at first discouraged and later forbidden; the study of Korean history was forbidden; and the Koreans were forced to abandon their traditional family and given names and adopt Japanese-style names. The very soul of the Korean people faced the danger of extinction.

The literature of Korea during this dire period was dominated by a form of poetry strongly influenced by the spare, melancholy verse of Mallarmé, Verlaine and Baudelaire. While the Symbolist movement, as it originated in France, was inspired by a lack of faith in the ability of words to convey meaning, for the Korean Symbolists, such speechlessness was rapidly becoming a political and everyday reality rather than merely an aesthetic conceit. Their elegant poems, whose somber mood matched the desiccated spirit of the time, also contained veiled protests, as in Kim Sowol's "The Summons of the Soul":

> *O name broken piecemeal,*
> *Strewn in the empty void*
> *Nameless name, deaf and dumb,*
> *That suffers me to die as I call it.*

Cha herself seems to have sought protection from the possibility of losing her language by resisting the security of learning and communicating in a single tongue. Reflecting her "consciously imposed detachment" from the English language, Cha interspersed her English texts with French, Korean and Latin words and phrases, often in a single sen-

tence. This interweaving of languages is present in her private journals as well as in her works of art. Thus, Cha made language a central theme of her work; in a statement written sometime after 1976, she explained:

> The main body of my work is with language, "looking for the roots of language before it is born on the tip of the tongue." Since having been forced to learn languages more "consciously" at a later age, there has existed a different perception and orientation toward language. Certain areas that continue to hold interest for me are: grammatical structures of a language, syntax. How words and meaning are *constructed* in the language system itself, by function or usage, and how transformation is brought about through manipulation, process as changing the syntax, isolation, removing from context, repetition, and reduction to minimal units. [Cha's emphasis]

Her attention to the nuances of language and the richness of its instability is expressed in several works in which she broke down individual words into their constituent semantic units and, through the use of graphic variation, emphasized hidden meanings. The single-channel video *Vidéoème* (1976), for example, begins with the following words and word fragments appearing sequentially on the screen:

VIDÉ
VIDÉ O
O ÈME

Cha constructs the title at the same time as she reveals its potent fractures. Translating from the French, we might read the passage: *vidé* = emptied; *vidé* o = emptied zero (this fragment, of course, also names the medium of the work while the "o" can be read imagistically as a circle, hence signifying an empty circle); o *ème* = very least. Similarly, *Exilée* begins with the following sequence:

EXIL
EXILE
 ILE
 É
 É E

Theresa Hak Kyung Cha, VIDÉOÈME, 1976

Cha demonstrates the variety of meanings embedded in the word, "exile": exile—a state of banishment or isolation; "ile"—island; and "é"—which, disassociated from a specific word, simultaneously signifies an abstracted notion of the female gender and embodies graphically a state of exile or displacement.

In 1976, Cha traveled to Paris to attend the Centre d'Études Américaines du Cinéma. By the time she arrived, a major shift in French film theory that had begun in the 1960s was fully under way. Following the lead of Jean-Louis Baudry, theorists such as Thierry Kuntzel and Christian Metz had greatly expanded on the standard structural linguistic interpretation of the film image common in France in the 1960s in order to include the entire "apparatus" of the film experience. That is, they sought a new theoretical model that would account for the various relationships among all the elements of the cinematic experience: filmmaker, camera, screen, screen-image, spectator and so forth. Their new paradigm, responding in particular to the desire to take into account the creative activity of the filmmaker and the psychological response of the spectator, consisted of a marriage between the old semiotic approach and contemporary psychoanalytic views.

Cha hoped to integrate film theory into her art-making practice. In an application for an extension of her grant to study in Paris, Cha wrote:

> It is essential for me to see the possibilities of filmmaking as an expression closely tied with other expressions supported by its theory as reference: to see the application of theory to actual works followed by a re-recognition, "realization" of the theory in practice.

Much like Jean-Luc Godard, Cha believed that theoretical and creative practices are congruent explorations, and she sought a form in which artist and theorist could speak the same language. This attempt at linking what are usually thought of as distinct modes of discourse is exemplified in *Apparatus* (1980), the anthology of film theory that Cha edited and designed for Tanam Press. The writers she included in this text are Roland Barthes, Dziga Vertov, Jean-Louis Baudry, Maya Deren, Gregory Woods, Danielle Huillet, Jean-Marie Straub, Thierry Kuntzel, Bertrand Augst, Marc Vernet and Christian Metz. In the midst of the volume, Cha inserted an artwork of her own, titled *Commentaire*, a text and photo piece that, like *Vidéoème* and *Exilée*, incorporates a deconstruction of its own title. In *Commentaire*, Cha plays on overlays of French and English meaning—a method quite common in her work, but particularly appropriate here in the context of a large number of essays translated into English from French. She builds a web of meaning around various

combinations and graphic alterations of words embedded in or philologically adjacent to *Commentaire*: "comment," "how," "taire," "tear," "commentary," "moment," "momentarily" and so on. Through various formal maneuvers, she mimics aspects of the cinematic apparatus as described by the various essayists. For example, her alternation of black and white pages creates an oscillation between dark and light that echoes cinema's "flicker effect" as described by Vernet. Another visual trope used in *Commentaire* is the placing of a black border around certain pages, which further concretes the correspondence between textual and cinematic discourse, and which recalls an observation by Baudry in *Apparatus*:

> No doubt the darkened room and the screen bordered with black like a letter of condolences already present privileged conditions of effectiveness—no exchange, no circulation, no communication with any outside.

For all of the close connections between Cha's work and the theories of Vernet, Baudry, Kuntzel and Metz, her work was based on a fundamentally different notion of the psychic apparatus, and therefore of the cinematic apparatus to which it had been analogized. For the French theorists, the psychic processes at work in the cinematic apparatus were understood essentially in terms of a diachronic narrative structure. This structure, which corresponds to the Lithuanian communication theorist A. J. Griemas's "actantial model," comes to the fore in Metz's essay "The Fiction Film and Its Spectators: A Metapsychological Study." Here Metz argues that at either pole of the cinematic apparatus lies the "sender" (or "the unconscious of the filmmaker") and the "receiver" (or "the filmic state"—that is, the spectator's unconscious). Griemas himself proposed four poles of the narrative process: the "sender," "subject," "object" and "receiver." These relate as follows: sender (of the subject on its quest for the object), subject (looking for the object), object (looked for by the subject) and receiver (of the object to be secured by the subject). Following Metz's lead, we can reasonably propose that the cinematic apparatus would fit into the actantial model something like this:

Sender: the filmmaker's unconscious
Subject: the screen image
Object: the spectator's perception
Receiver: the spectator's unconscious

The critical difference between this conception and Cha's is that for Cha, sender and receiver were always already related. She began with the premise of a shared collective consciousness, and was able, therefore, to short-circuit the linear, narrative and atomistic aspect of the cinematic apparatus as understood through the actantial model. Furthermore, one can understand Cha's conception of her relationship as an artist to her audience in terms similar to those which, as we saw in *Dictée*, she sought to weave—or perhaps reveal—around her, filial relations, spun not by a network of blood and genes, but by the all-embracing force of a desiring consciousness. Evidence of this conception, which we might call a kind of meta-Confucianism, can be found in a body of related works—including an unbound book, a published text piece and a wall-mounted installation—from 1977.

These pieces begin with a page that reads:

> letter
> sendereceiver

In Cha's typically deceptively simple play on the double meaning of the word "letter," she indicates that that which connects the two polar terms of the actantial model is always already in union with them, as they are with each other. She alludes as well to Griemas's other two terms, "subject" and "object," leaving these similarly deconstructed:

> in our relationship
> i am the object/you are the subject

> in our relationship
> you are the object/I am the subject

> in our relationship
> you are the subject/I am the object

> in our relationship
> i am the subject/you are the object

audience
distant
relative

letter

senderecelver

object/subject

messenger

between

delivery

echo

Theresa Hak Kyung Cha, AUDIENCE DISTANT RELATIVE, 1978

For Cha, the artist was no more, or no less, the "sender" than the audience, or even the materials (the screen image, etc.), were. In *Audience Distant Relative* (1978), she describes the layering of consciousness experienced through a work of art:

This is a letter read aloud
upon opening it
you hear the sender's voice as your eyes move over the
words you, the receiver, seeing the sender's image
speak over the
voice.

The piece concludes:

you are the audience
you are my distant relative
i address you
as I would a distant relative
as if a distant relative
seen only heard only through someone else's description.

neither you nor i
are visible to each other
i can only assume that you can hear me
i can only hope that you can hear me

For Cha, establishing such links of pseudo-genealogy was only a means by which to engender a recognition of collective consciousness among all the participants, and thereby to point toward a larger experience transcending the individual ego. Contrary to the French theorists' model of the cinematic apparatus—in which the needs of the participants are served through the reiteration in various ways of infantile moments of individual psychic formation—Cha seems to have envisioned the "cinematic" experience as a kind of alchemical ritual in which the participants transcend their individuality to find greater knowledge through access to the "*collective* memory and imagination." [my emphasis]

Cha articulated this position in a paper, titled "Paths," which she submitted as part of her M.F.A. thesis in 1978:

The artist's path is close to that of an alchemist in that his/her path is that of a medium. His/her vision belongs to an altering, of material, and of perception. Through this attempt, the perception of the audience has the possibility of being altered, of being presented a constant change, Re volution.

She goes on to quote Ekbert Faas:

For most, the pursuit of literature and art is simply a vehicle of the Way, which, besides the notion that poetry expresses the "intent of the heart" (or mind), is the most widely quoted principle of Chinese poetics. And the Way is as long as the mind is deep, comprising, as Buddhist philosophers knew long before Jung, not only the personal "mind-system," but the huge memory storehouse of the "Universal Mind" in which "discriminations, desires, attachments, and deeds" have been collecting "since beginningless time" and which "like a magician cause phantom things and people to appear and move about."

This passage reveals the conceptual framework within which Cha would have reconciled the individual psychic activities, such as those described by Baudry, Kuntzel and Metz, within an overall framework of a so-called "Universal Mind." Her understanding of the psyche, of film and of art in its broadest sense was as phenomena capable of bridging here and there, past and present, self and other.

Cha's art is testimony to her ability to translate a personal experience of profound personal and cultural displacement into a foundation for exploration into universal aspects of language, memory, communication and consciousness. In a statement from 1978, Cha wrote:

My work, until now, in one sense has been a series of metaphors for the return, going back to a lost time and space, always in the imaginary. The content of my work has been the realization of the imprint, the inscription etched from the experience of leaving.

In typically elliptical fashion, Cha leaves the final verb "leaving" without an object. As she does in her most successful works, Cha achieves here, even in this ostensibly didactic explanation, a sense of suspension that confers the potency of her own experience, while evoking for the reader what Roland Barthes called "a plurality of entrances, the opening of networks, the infinity of languages."

IN THE 1960S, MANY ARTISTS BECAME ENGAGED WITH HISTORICAL, PHILOSO-phical or political concerns that inspired them to seek alternatives to the object as the end result of artistic practice. Whether these concerns were based on notions of art-historical progress, linguistic or analytic philosophy, or anti-capitalist politics, artists around the world increasingly came to depend on the impalpable concept as the substance of art. However, finding it impossible (or simply uninteresting) to let the art object vanish into the empyrean of pure Idea, artists of the 1960s and 1970s continued to use everyday materials to ground their immaterial concerns in the stuff of human perception and life experience. As noted by Carin Kuoni, "Their explicit acknowledgment of the importance of the physical aspect of the work places them squarely in the contested zone where the call to make an immaterial philosophical statement spars with the desire to create an actual work, using nontraditional, ordinary materials."

After a return to painterly expressionism in the 1980s, artists in the 1990s began to turn to the art of the 1960s and 1970s again in search of models of practice that were both conceptual and material, participatory and ephemeral, critical and sensuous. Young artists today have absorbed the lessons of Conceptualism and seem comfortable taking these strategies for granted as they work with a variety of approaches in the manipulation of physical material. The renewed interest in the achievements of an earlier generation has been fueling some of the most compelling art at the turn of the millennium.

Perhaps the most common tension surrounding the art object in the 1960s and 1970s (at least in the non-Communist West) was its status as a commodity. The move away from objects was often tied to an effort to subvert art's commercial status and return it to a purely social or aesthetic function. Many artists paid no attention to the art market, creating works that were difficult if not impossible to sell. Others, such as Marcel Broodthaers, Piero Manzoni and Cildo Meireles, positioned their art within the economic

system so that it could play a critical or subversive role. In the 1990s, artists began to address these issues again; however, for the most part their approach has been to embrace the monetary system of exchange as a neutral vehicle—a "primary structure," if you will—to be shaped and molded according to the requirements of a particular piece.

Among the most important examples of such practice are works by the American collective RtMark and by French artist Fabrice Hybert. Physical objects are essential components of the art of both: for RtMark, in terms of destruction; for Hybert, in terms of play. RtMark encourages the "alteration" of commercial products, especially children's toys, games and learning tools. Their first highly publicized project involved channeling funds to the Barbie Liberation Organization which, in 1993, switched the voice boxes of three hundred G.I. Joe and Barbie dolls. Another notorious bit of commercial sabotage funded through RtMark was the reprogramming of eighty thousand copies of the popular electronic game Simcopter, which was altered to include homoerotic content. Like the modified Coke bottles in Cildo Meireles's *Insertions into Ideological Circuits: Coca-Cola Project* (1970), these products were returned to the stores to make their way into consumers' hands and homes. On their website, RtMark.com, the collective provides news and information, parodying political and corporate propaganda, and allows visitors to invest directly in one of their "mutual funds," which finance the group's subversive actions.

RtMark, BARBIE LIBERATION ORGANIZATION, 1993

Hybert takes a less risky but no less subversive approach to commenting on the market-driven dimension of art production. His recent objects (which he calls "Prototypes of Functioning Objects" or POFs) are intended to inspire new behaviors through the user's own imaginative, physical interaction with the pieces. The POFs recall Hélio Oiticica's anarchic *Parangolés*, 1964–1967, wearable or inhabitable art forms that Oiticica believed could facilitate a more creative experience of everyday life by disrupting behavioral norms and unlocking a kind of latent *jouissance*. However, the overtly—even

ecstatically—commercial dimension of Hybert's project would have been unthinkable in the 1960s and 1970s. Hybert has created a fully functioning business, Unlimited Responsibility (UR), as a vehicle for the development and marketing of his POFs. He employs a kind of reverse industrial-design process: instead of creating forms to meet the needs of new behaviors, Hybert develops behaviors to meet the needs of new forms, such as a cubic soccer ball. By means of audience-survey forms, he tracks possible "uses" of the POFs, pinpoints particularly successful objects and then generates new ones. It would be a mistake to see Hybert's work simply as market research, with his audience functioning as a kind of amorphous focus group.

Fabrice Hybert, P.O.F. #3—SWING, 1993

Ultimately, his work is more about fantasy than reality, or, perhaps, fantasy in reality. Of this process, Hybert has said, "Nothing creates itself, everything transforms. The artist is there for charging these transformations with meaning and humanness. The main thing is . . . the possibility of . . . a revalorization of forms, and a reevaluation of commodities (objects or services) that surround us."

Many artists of the 1990s, like those of the 1960s and 1970s, focus on art's interactive, instrumentalist potential. In the 1960s and 1970s, Latin American artists in particular emerged from the formalist box of high Modernism into an expanded field of social engagement. Both Oiticica and Lygia Clark, for example, transformed Concretism—a practice dedicated to the reduction of form, color and shape to what were conceived as perceptually direct or absolute aesthetic conditions—by playing out its premises to their fullest extent. "It was during his initiation to samba," writes Simone Osthoff, "that [Oiticica] went from the visual experience in all its purity to an experience that was tactile, kinetic, based on sensual fruition of materials, where the whole body, which in the previous phase was centered on the distant aristocracy of the visual, became the total source of the sensorial." Clark, meanwhile, moved progressively from considerations of external form to explorations of internal experience, which ultimately evolved into a highly interactive, psychologically therapeutic art.

Like Oiticica and Clark, Chicago-based artist Iñigo Manglano-Ovalle creates participatory sculptural environments that are designed to catalyze spontaneous human relationships and transformative experiences. Pieces such as *The El Niño Effect* (1997) and *SAD Light Room* (1999), call for pairs of spectators—often strangers to one another—to engage

with the work on both a physical and a psychological level. *The El Niño Effect* consists, in part, of two sensory-deprivation tanks that can be occupied for periods of up to an hour in a state of deep meditative self-awareness. The vaguely New Age aspect of the work is undercut by the presence of a soundtrack that may seem to the casual viewer like breaking waves, but which is actually the much-slowed-down echo of a gunshot. *SAD Light Room* similarly presents a kind of therapeutic social encounter with an ironic undercurrent. In this piece, two spectators recline on side-by-side, white, high-modern chaise lounges, while from above they are bathed in a specially balanced light. This light, known as SAD (Seasonal Affective Disorder) light, has been developed to cure depression in people who live in parts of the world that receive too little sunlight each day during the winter months. While *SAD Light Room* exists ostensibly to cheer up the grumpy spectator, the environment that the artist has created is uncomfortably sterile and intentionally vacuous. The

Iñigo Manglano-Ovalle, SAD LIGHT ROOM (Public Service Full Spectrum Light Therapy), 1999

irony and ambiguity of Manglano-Ovalle's work distinguish it from the considerably more idealistic and utopian art of Oiticica and Clark.

Joseph Grigely is another contemporary artist creating art that is inseparable from

social interaction. Grigely, who has been deaf since the age of eleven, makes his art—which he calls "Conversations with the Hearing"—from the brief notes passed to him by various interlocutors: friends, acquaintances and strangers. Grigely assembles these small pieces of paper into groups, drawing subtle links between the discontinuous texts and making purely formal connections based on such properties as color. His accumulations

Joseph Grigeley, UNTITLED CONVERSATIONS (SUSAN'S MARTINI PARTY), 1996

of notes are an interesting counterpoint to the cryptic text pieces that Croatian artist Mangelos created during the three decades from World War II through the 1970s. Although Grigely's art may seem offhand and whimsical in comparison to the existential weight of Mangelos's practice, the work of both metonymically alludes to a larger universe of thought and experience and shares an underlying engagement with a profound sense of absence. Mangelos's first pieces, for example, consist of pages on which he recorded the deaths of neighbors, friends, cousins and acquaintances. In Grigely's work, a haunting silence overtakes us as we come to realize that the only person whose comments are not present is the artist himself.

Another strong current connecting the 1960s and 1970s to contemporary practice is

a genre of work that incorporates everyday, sometimes found, materials to create provocative interventions in daily experience. Since 1970, Polish artist Edward Krasiński has created art almost exclusively from blue Scotch tape, 3/4–inch wide and applied to just about any surface in his vicinity (trees, walls, windows, etc.) at a constant height of 51 1/8 inches. With this simple repeated gesture, Krasiński combines the rigor of concrete art and Conceptualism with the absurdity and humor of Surrealism and Dada. According to Krasiński, "[The stripe] unmasks reality to which it is stuck. . . . It can appear anywhere. . . . Through pure picture and the blue line I sanction a given place as the place of art." A contemporary counterpart to Krasiński (who is still putting up his blue tape) is Martin Creed, a young English artist who similarly marks spaces with simple interventions that are simultaneously measured and ludicrous. A typical Creed piece is *Half the Air*

Martin Creed, WORK NO. 200: HALF THE AIR IN A GIVEN SPACE, 1998

in a Given Space (1998), which consists simply of balloons that have been filled with exactly half the volume of air in a given space in which the work is shown. This seemingly innocuous, even festive, act turns into an exercise in terror and claustrophobia when spectators find themselves unable to escape the suffocating, balloon-filled environment. Like Krasiński, whose blue tape may wend its way through a group exhibition, Creed has created ambient works that borrow the space around them, including, at times, the works of other artists. Creed's sole contribution to a recent group exhibition, for example, was a piece that consisted of turning the gallery lights on and off at regular intervals.

Andrea Fraser is even more radical than Creed in her rejection of conventional artistic forms and critical embrace of quotidian experience. Recalling project-based works such as Mierle Laderman Ukeles's *Maintenance Art Project* (1969–1970)—or Gordon Matta-Clark's SoHo restaurant *Food* (1971–1973)—Fraser has developed a practice that involves responding to various requests for services. In 1994, for example, she was hired to study the function of the art of the Generali Group Austria and the programs of the Generali Foundation. Her re-

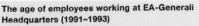

The age of employees working at EA-Generali Headquarters (1991–1993)

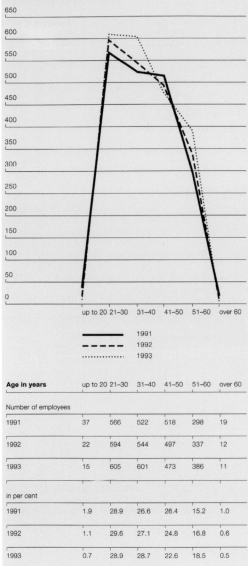

	1991
	1992
	1993

Age in years	up to 20	21–30	31–40	41–50	51–60	over 60
Number of employees						
1991	37	566	522	518	298	19
1992	22	594	544	497	337	12
1993	15	605	601	473	386	11
in per cent						
1991	1.9	28.9	26.6	26.4	15.2	1.0
1992	1.1	29.6	27.1	24.8	16.8	0.6
1993	0.7	28.9	28.7	22.6	18.5	0.5

Board of Directors: In the last five years, many of the Foundation's aims have been achieved. But the most important thing is that I'm sure far more than 50% of the young people like the idea of the Foundation and, well, the old ones are going to die, anyway. It's the younger generation that counts.

Notes
[1] Franz Kafka worked for Assicurazioni Generali Prague between October 1907 and Juli 1908.
"No, I don't get too worked up about the office; the obvious justification for my irritation is that it has survived five years of office life, of which the first in a private insurance company from eight a.m. to seven, to eight, and eight-thirty p.m. was particularly awful, boo! There was a certain place in a narrow passage leading to my office where almost every morning I used to be overcome with such despair that a stronger, more consistent character then mine might have committed suicide quite cheerfully."
[Franz Kafka, as quoted in Jiří Gruša, *Franz Kafka of Prague*, trans. Eric Mosbacher (London: Secker & Warburg, 1983) 64.]

Notes
[1] Pierre Bourdieu, *Distinction: A Social Critique of the Judgment of Taste*, trans. Richard Nice (Cambridge: Harvard University Press, 1984) 3.
[2] Sabine Breitwieser, "Field Research at the EA-Generali," in *Heimo Zobernig* (Vienna: EA-Generali Foundation, 1991) 9.
[3] Linda Smirch, "Concepts of Culture and Organizational Analysis," *Administrative Science Quarterly 28* (1983): 342-45.
[4] The Training Department of EA-Generali AG, *Basis II* (Vienna: EA-Generali AG, 1994) 97.
[5] The EA-Generali Group, *Unternehmerische Leitstrategie der EA-Generali Unternehmensgruppe [Core Corporate Strategy of EA-Generali Unternehmensgruppe]* (Vienna: EA-Generali AG, 1992) 25.

Staff Council: It isn't very polite to say this, but the Foundation isn't really such a big topic. People know more about tennis sponsorship—and are much more interested in it—than the Foundation.

69

Andrea Fraser, A PROJECT IN TWO PHASES (The EA-Generali Headquarters, Vienna), 1994–95

search involved exhaustive interviews with staff and board members, analysis of information from many of the company's departments, and consultation with the Foundation's archives. The first phase of her service was completed in the form of a document resembling the corporation's annual report and published by the foundation. The second phase, which was defined as "interventionary," involved transferring all of the art displayed on the walls of the corporation's headquarters to the Foundation's gallery, installed in the same order in which it appeared in the corporate offices. As described by Fraser, this action resulted in two installations: "the corporate headquarters stripped of its artistic gloss, and the 'collection' returned to the art world, but in its form as office furniture." Fraser's work, which doesn't shy away from a critical engagement with the commissioning institution, echoes Hans Haacke's anti-institutional investigations, although Fraser positions her art subversively within the very system of corporate, capitalist enterprise that she critiques. Fraser's most recent work, *Untitled* (2004), is simultaneously an incisive commentary on the intersection of art and commerce and a remarkably revealing self-portrait. This one-hour-long video documents her assignation with an unnamed art collector who paid $10,000 for the opportunity to have sex with her and thereby participate in the creation of a new work of art. Although critics have responded primarily to the critical aspects of this provocative piece, it can also be seen in the tradition of Lygia Clark's interactive, therapeutic performances.

The response today to the art of the 1960s and 1970s is often indirect and sometimes even based on a faulty sense of history. In *an inadequate history of conceptual art* (1999), Silvia Kolbowski borrows the analytical, affectless mode of some 1960s Conceptual art to investigate contemporary artists' anecdotal recollections of the art of those earlier decades. In her letter to artists who were potential participants in the project, Kolbowski wrote:

> The focus of the project is the current resurgent interest in Conceptual art of the 1960s and 1970s, and this work's reappearance in various forms in galleries, museums, international shows, the media, the academy and the work of a new generation. . . . Compared to the 1980s, when such work was barely mentioned in the U.S., this new interest seems significant. The project seeks to question the seamless nature of the current "return."

Kolbowski's finished piece consists, in parts, of audio recordings that she made with twenty-two artists—most of whom were themselves involved with Conceptual practices in the 1960s and 1970s—in which they describe Conceptual works that made a powerful ini-

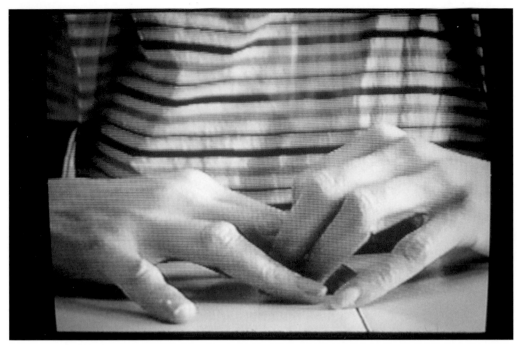

Silvia Kolbowski, AN INADEQUATE HISTORY OF CONCEPTUAL ART (video still), 1998–99

Silvia Kolbowski, AN INADEQUATE HISTORY OF CONCEPTUAL ART (installation view), 1998–99

tial impression on them. As we listen to the recorded sessions, we become aware of the imprecision of their recollections of works that often were created with little or no material form. In addition to the audio component, Kolbowski's piece includes a laser-disc projection showing images of the artists' hands as they speak. Their hands are not synchronized with their voices, which becomes evident, for example, when we hear a man's voice and see a woman's hands. Furthermore, the audio and video components—the former played on a high-end Bang & Olufsen sound system and the latter on a relatively low-tech, floor-mounted three-beam projector—are played in separate, adjacent rooms. Through such disjunctions, Kolbowski suggests an underlying fracture of perception and understanding, while commenting on the difficulty—if not impossibility—of establishing an unmediated connection to our aesthetic forebears.

Although our digitized, post-Cold War world bears little resemblance to the Europe of Joseph Beuys, the Brazil of Lygia Clark, the Soviet Union of Ilya Kabakov or the United States of Eva Hesse, the art of the 1960s and 1970s has captured the imagination of a new generation of international artists. While many of the lessons of the 1960s and 1970s remain valid, it would be foolish to assume that these earlier strategies can be simply and uncritically adopted in the present. Despite their similar balancing of material and concept, the artists of the 1960s and 1970s were engaged with a diversity of profoundly local social, political and cultural issues. With the explosion of large-scale international survey exhibitions and the accompanying globalization of the contemporary art market, the tendency of more recent art is to lose that specificity. Art has come unmoored from its locales to float freely and ambiguously in a global art world that is increasingly self-aware and self-referential. In this atmosphere, it is becoming increasingly difficult to tell one artist's work from another. Rather than see this as a problem, and long nostalgically for the intense if relatively atomized conditions of the 1960s and 1970s, we must face the reality of the present and come to terms with the conditions produced by the expansion-driven art market, art media and art institutions, which—paradoxically—are both energizing and enervating. The single most important lesson that can be gleaned from the work of the 1960s and 1970s is its anti-dogmatism. Artists are increasingly inspired by works that succeed in weaving dualities together: conceptual and material, public and private, and commercial and altruistic dimensions. It is in the complex arena of dynamic, fluid identities, rather than in the comforting territory of solipsism and style, that the most innovative and influential works of the early twenty-first century will be made.

IT IS DIFFICULT TO SAY PRECISELY WHAT IRIT BATSRY'S WORK IS "ABOUT." AS A visual expression, it exceeds the power of language to unravel and describe its essence. No description of her complex and nuanced art can possibly describe the hows and whys of its power and meaning. Still, there are characteristics of this work that can be identified and that, once verbalized, confirm the impression that we are looking at something rare and

Irit Batsry, MAKE: MEASURE 2, from SET, 2003

Irit Batsry, MAKE: MEASURE 1, from SET, 2003

important. In the broadest terms, Batsry's aim, over the past decade, has been to investigate the construction and perception of images. Since our experience of reality is mediated by images, this investigation is inextricably linked to the question of how we experience life itself. Fundamentally, then, Batsry's art is existential, reflecting on the nature of being. In this sense, her work is profoundly philosophical. By using images to investigate images, she engenders in the viewer both a deepened sensual acuity and a heightened self-awareness.

Formally, Batsry's art exemplifies one of the most significant recent aesthetic tendencies, which is the movement toward mixed media or, in the words of Gilles Deleuze, the "between method." Combining elements of architecture, film, video and sculpture, as well as references to painting and poetry, Batsry creates a unique expressive fabric. While such multivalency is familiar now in work from Theresa Cha to Matthew Barney, for Batsry the most important precedent and model for genre hybridization are the films and videos of Jean-Luc Godard. Godard's radical approach to image-making was, in the words of John

Irit Batsry, MAKE: MEASURE 1, from SET, 2003

Conomos, "a discursive, trans-media view of cultural production that [criticized] the dualistic constraints of Modernism and official culture." Godard broke almost every rule of filmmaking in an effort to more closely approximate the experience of perception and being. His approach, however, was not to plumb the expressive depths of the subconscious but, rather, to seek in the very process of image-making itself clues to the drives that constitute our passion for life and love. For Godard, to make a film, including the most technical aspects of lighting, blocking and shooting, was to discover the uncanny connection between image and experience.

Like Godard's, Batsry's work is invariably self-reflexive; that is, each piece contains a commentary on its own creation, expressing the logic and history of its existence. Her work has taken several forms: single-channel, gallery-based videos; feature-length, cinematic videos; and multimedia installations. In each case, the specificity of not only the medium, but the work's setting and content is called into question. No matter what the ostensible "subject" or thematic content of her work, Batsry's art always brings the viewers'

Irit Batsry, REFLECT, from SET, 2003

attention back to their own experience in the present, their own processes of seeing and comprehending. Thus, her installations, for example, always respond to the physical, aesthetic and cultural aspects of their particular site. In contrast to a more doctrinaire methodology of site-specificity, however, Batsry introduces imagery and, occasionally, sounds that complicate or confuse the physical or temporal location of her project. She opens a space for the viewer that is both deeply poetic and rigorously analytical.

These Are Not My Images (Neither There Nor Here), featured in the 2002 Whitney Biennial, was Batsry's first feature-length work. In the artist's words, the video "interweaves elements of different genres (documentary, essay, experimental, narrative) in order to question the way we see and show reality." The narrative consists of the voyage of a disillusioned Western filmmaker to the southern Indian state of Tamil Nadu, accompanied by a half-blind guide, and her encounter with a local filmmaker. The boundary between truth and fiction is blurred, as the perspective of the narrator oscillates between Batsry herself (the Western filmmaker?) and these other imaginary characters. Set in a distant country in

Irit Batsry, MAKE: MEASURE 2, from SET, 2003

the near future, *These Are Not My Images* evokes a powerful feeling of suspension, of being held between places, between times and between identities. Reflecting an important recent tendency in the documentary field, *These Are Not My Images* complicates the veracity of this nominally objective genre. Although Batsry's video was funded by a documentary production company and has been screened in documentary film festivals, it presents a highly ambiguous vision of reality. The footage itself is modified using in-camera and digital editing to create a highly impressionistic and indirect view of her subjects and settings. The soundtrack, meanwhile, was created by Stuart Jones, a renowned composer, performer and sound artist whose work interweaves influences from the Western avant-garde (Cage and Stockhausen) to traditional non-Western music (Ghanaian drummer Mustapha Tettey Addy) to innovative architectural practices (Norman Foster and Partners). "How much 'reality,'" Batsry asks, "do the transformed images and sounds retain? Are framing and editing less deforming than electronic manipulation of images?"

After completing *These Are Not My Images*, Batsry produced a new site-specific instal-

Irit Batsry, SETUP, from SET, 2003

lation in Montreal, at the Biosphere, a museum dedicated to the observation and safe-guarding of water, situated in the former Expo 67 U.S. pavilion. The piece, called *Fuller's Flow*, was inspired by "the unique architecture of the site, the utopian vision of its architect, R. Buckminster Fuller, and the element of water." The piece consisted of several sites and components. Inside the building itself, she installed multiple projections on screens and on walls of streaming water. "A parallel is created," she explains, "between water and the electronic image, both being a flow, a stream, an energy. The constant movement of the images and the flow of water blur the boundaries between solid and liquid, and create a unique perception of space, in a tribute to the one created by Fuller's architecture: the feeling of being outdoors and indoors at the same time." Meanwhile, outside the building, Batsry projected a video loop of archival images of the Expo 67 monorail entering and exiting the building, thereby suggesting a layering of history and time.

Set is a site-specific, multimedia installation created during the artist's two-year resi-

dency at the Whitney Museum. While the installation itself was developed during her residency, the footage that makes up the installation's imagery was shot, in the summer of 2001, during the filming of Karim Ainouz's *Madame Sata* in Brazil. Ainouz, who was himself represented in the 1995 Whitney Biennial, was also a student of Batsry and has expressed his indebtedness to her work, especially *These Are Not My Images*. When Ainouz was about to begin shooting his own first feature-length film, he invited Batsry to join him on the set to make a work of her own.

Madame Sata, which was written and directed by Ainouz, tells the real-life story of Joao Francisco dos Santos, a child of ex-slaves who led an extraordinary life in the slums (and prisons) of Rio de Janeiro in the 1920s and 1930s. He was both a female impersonator, renowned for his flamboyant performances during Carnivale, and the father of seven adopted children. "Madame Sata" is the stage name dos Santos adopted for himself from Cecil B. DeMille's film *Madame Satan*. In *Madame Sata*, dos Santos is vividly portrayed by

Lazaro Ramos, who conveys both the beauty and vulnerability of this tragic figure. "*Madame Sata* was to *Set* what India was to *These Are Not My Images*," explains Batsry. That is, it is a symbolically rich starting point for an investigation into a wide range of issues concerning the production and reception of images.

Set, writes Batsry, "evokes the tension between the artifice and the real, and between the projected and the painterly image. The installation involves multiple projections, which depict the making of a feature film from both sides of the camera, bringing the viewer up close to the actor, cameraman and location, and relocating the viewer somewhere between the fiction of cinematic space, and the reality behind its construction." Specifically, *Set* consists of seven silent video projections, which were arranged on the floor around the periphery of the Whitney's film and video gallery. Each projector is equipped with a custom-designed Plexiglas screen, which allows the image to pass through and be seen on the adjacent wall while simultaneously causing a reflection that is cast at an oblique angle across the room to an opposite wall. Since the projectors are placed within a few feet of the wall, the projected images are unusually small in scale, suggesting, in Batsry's description, a size more familiar to paintings than to cinema. Their presentation, sometimes in diptychs, around the walls of the room, further emphasizes this relation to the conventional display of static, two-dimensional works. The reflected images, meanwhile, are much larger, since they are cast across space, and at the Whitney, they alluded to the historically cinematic function of the film and video gallery itself.

The tension between the film (or video) and the static, two-dimensional image extends to the content of the projections themselves. Two of the projections, for example, which are arranged as a diptych, represent moments in the making of *Madame Sata* when the lead actor, Ramos, is being measured and made up for a shoot. Stoically suffering these obligatory preparations, his body and face suggest a combination of patience and intensity as he internally prepares for the ensuing emotional scene. Batsry selected these moments from hundreds of hours of footage because of their echo of critical moments in the history of painting and photography. The application of makeup to Ramos's face, while another assistant adjusts his costume, recalls for Batsry the rich heritage of painted images of Christ's suffering, and the attendance to his wounds. Specifically, she points to images such as Annibale Carracci's *Pieta* (1599–1600) and Nerezi's *The Lamentation of Christ* (1164) as inspiration. The measurement scene, meanwhile, evokes comparison to photography's original role as a tool for the relative measurement and classification of criminals

and deviant social types. Thus, through subtle means, Batsry elicits multiple resonances of the marginalized social subject, from Christian themes of consolation to contemporary techniques of categorization and control.

Another diptych of projections juxtaposes a twenty-minute, documentary-style video recording various aspects of the production of the cinematic image, including blocking, lighting and shooting, with a relatively short impressionistic loop representing abstract effects of light and shadow. Of all the projections in this installation, the former comes the closest to the "Making of . . ." genre that includes films such as Les Blank's *Burden of Dreams*, which documents the production of Werner Herzog's *Fitzcarraldo*. Yet, Batsry is adamant that this is not a "Making of . . ." video, but rather must be seen in the context of her larger project concerning the construction of images. The juxtaposition of this relatively didactic projection with a poetic video exploration of light and shadow alludes to this more fundamental concern. The fifth projection consists of imagery of the daily rushes of *Madame Sata*, screened on a video monitor for the benefit of the director, actors and crew. In this segment, Batsry's perspective oscillates between the artistic vision of Ainouz himself (when the imagery of his film fills Batsry's own frame) and her own, distanced view (when her shot pulls back to reveal the setting of the video monitor and the presence of the viewers engaged in review and analysis).

Among the inspirations for *Set*, Batsry points to Godard's film *Scenario du film Passion (Script for the film Passion)*, another pseudo-"Making of . . ." film in which Godard suggests that the script, or secret, of a film cannot be expressed in anything but another sequence of images. "Godard," writes Conomos, "is an author who needs to create cinema and video as a continuous dialogue, a theater of memory, infusing the image with language and quotations." In this layering of memory and quotation, Godard, like Batsry, sought inspiration in parallel fields. *Passion*, for example, is partially inspired by Tintoretto's painting *Bacchus and Ariadne*, and concerns a Polish film director re-creating in *tableaux vivants* paintings by Goya, Rembrandt, El Greco and others. Thus, a kind of imagistic chain of being is born, one in which individual authorship and the boundaries between media are blurred.

Batsry, too, casts the viewer into a provocatively indeterminate space, a space that aptly reflects the theme of her decade-long project, *Neither There Nor Here*. The ostensible subject of *Set*, Ainouz's film *Madame Sata*, slips away from us, even as we watch Batsry's five-channel investigation. What takes its place is a compelling experience of imagery un-

Irit Batsry, MAKE: MEASURE 2, from SET, 2003

der construction, construction that is simultaneously social, mechanical and mysterious. She creates an atmosphere that is as contemplative as it is didactic. In a 1957 review describing Jean Renoir's film *Elena et les hommes*, Godard could as easily have been discussing Batsry's *Set*: "Art and theory of art at one and the same time; beauty and theory of beauty; cinema and apologia for cinema."

NATHALIE SARRAUTE CALLED THEM "TROPISMS"—THOSE INDEFINABLE MOVEMENTS just below the surface of consciousness that course through human situations and make us who we are. Sleep, we might say, is a surrender to the tropic force, a surrender to the going toward as distinct from the need to arrive. Waking language has an object, a will to succeed. Sleeping thought relishes a detour and, contrary to Lacán, in the great mail service of sleep, the letter does not always reach its destination.

Kevin Larmon, FIGURE #6, 1990

Kevin Larmon's paintings are sleepy. They are warm and moist and just a bit stuffy. These are paintings of what happened *in* Rauschenberg's Bed. (Larmon's upturned tablecloths are Rauschenberg's downturned bedsheet.) Which is not to say that Larmon paints dreams. This is no fantasy world he shows us. Rather, and again, it is the "going toward" of a reasonable man: the image of what happens on the way.

What happens is often sex. Libido is so palpable in Larmon's paintings that one has the distinct and impossible impression of sex preceding figura-

Kevin Larmon, A DEFINITION, 1990

tion. Whereas Rauschenberg gave us aftermath, Larmon provides the before and during. Some old Dutch still lifes combine blooms from several seasons: such is the all-over desire-time of Larmon's art.

In Larmon's paintings there is almost always an apple and a pear. As a constant motif, the fruits serve as a key and an anchor to the artist's work. Redolent with symbolic value—mind/body, commonness/luxury, male/female—their dualistic themes soak into the broader compass of the paintings, informing the plays of thick and thin, warm and cool, seduction and repulsion. Sometimes the apple looks like an egg; sometimes the pear looks like a skull. In Larmon's later work, the fruits are luminous and smooth and, separated from the bowl that used to hold them, appear strangely naked and vulnerable: they no longer seem to nestle so much as cling.

Repeated ad infinitum, however, the fruits seem to slip away from meaning. They become strange, like a familiar word repeated over and over and over again, and float, literally and figuratively, unmoored from understanding. Thus, the most representative element in Larmon's work becomes the most abstract. Reduced to a "meaningless" device, this compulsively repeated form regains significance in its mediating capacity among the paintings. Thus, as we come to compare this fruit to that fruit, a level of interest comes to light that skips across the oeuvre, perpendicular to the intensity of contemplation of a particular work. The fruits lead us both into and out of the paintings.

Larmon's paintings have always contained references to the human figure, either through collaged images from art books and sex magazines or, in a more abstract sense of personhood, through his use of symbolic elements, such as pages from the New York City phone book, which he once used as a ground for his thick impasto. Larmon began painting the human form in 1986 in a series of watercolors. As in those works, the figures in his most recent oil paintings are loosely based on studies by Michelangelo. While something of the robustness of Michelangelo's contours is conveyed, Larmon's overall effect is, by contrast, rather wispy. Indeed, the transparency of Larmon's shadowy figures recalls Lucretius's analysis of the image as a "sort of skin perpetually peeled off the surface of objects and flying about this way and that through the air."

Underlying Larmon's imagery is a grid-like structure that plays at organization while paying homage to Mondrian, one of the artist's less likely guides. In fact, at one point in the early 1980s, Larmon's works were pure geometry, their palette limited to red and black. Here, the orderliness of his compositions depends less on a strictly drawn grid than on a gentle push and pull of rectangular passages defined by cutout collage fragments, the

Kevin Larmon, FIGURE #7, 1990

edges of abutting canvases, painted areas—such as the recurring square of an upturned tablecloth—and a light, wavering web of thin black lines and coagulated drips. By occasionally allowing the strands of these webs to give out before reaching the edge of the canvas, Larmon holds the grid itself in a delicate balance between architecture and image, foundation and apparition. This very strategy was familiar to Mondrian, and it can be

helpful in understanding the link between these two artists by remembering that the rigorous Dutchman was initially influenced by the Symbolists.

Kevin Larmon's paintings are equally sensuous and philosophical, and become "realistic" thanks to this rapprochement. The full texture of life, his paintings tell us, is found only when the warp of contemplation and reason are woven together with the weft of drowsiness and steamy seduction.

Kevin Larmon, SPENCERTOWN, NEW YORK, 1990

MOST PEOPLE THINK THEY HAVE TO CHOOSE BETWEEN REALITY AND FANTASY. In a sense, the whole purpose of childhood is the slow and often painful separation of children from their dreams. And if that doesn't work, there is always psychoanalysis later on. We strive for rationality, for a sense of order and purpose. We want to be able to discuss our goals in the clear light of day.

Samuel Mockbee and The Rural Studio, THE LUCY HOUSE, 2001–2

Anderson and Lucy Harris and family, THE LUCY HOUSE (interior), 2001–2

Our society makes some room for people who don't want to leave their dreams behind, safely stored in sleep. They can be artists, writers or musicians but not much else. Certainly nothing practical. We don't want people who have trouble distinguishing images from things driving our buses, trimming our trees or installing our phones. Plato came down hard on these types and we still do.

So, imagine an architect—not just an architect, but a community builder and an advocate for social change—whose work depended on an engine of fantasy known almost only to himself. Who saw in his colleagues and clients embodiments of fantastical characters imbued with mythic purpose. Whose work in the world, celebrated as a model for progressive design, building and education, may have been simply the cast-off foam from a vast imaginative sea.

This was Samuel Mockbee. When I went to see Mockbee in the summer of 2001, we spent a day driving around Newbern, Alabama and adjacent towns, visiting the inhabitants of half-a-dozen of the great Rural Studio-designed homes. The picture I formed of

his project was one of almost utopian clarity. Here was a man with the vision, the will and the resources to change a corner of the world. And to do so with as simple an idea as dignity. It all seemed so open and clear, yet there was madness to his method.

At the end of our long, hot day together, Mockbee decided to take me to his studio, which was not, as I had expected, a space devoted to architectural models and sketches. No, it was a place of fantasy: raw, mythic, uncensored images of the people we had just seen, the everyday inhabitants of the Rural Studio homes. Painted, collaged and cobbled together from branches and other found materials, these portraits and tableaux presented Mockbee's inner vision of his clients revealed as characters in an uncertain yet timeless drama of passion, love and pain.

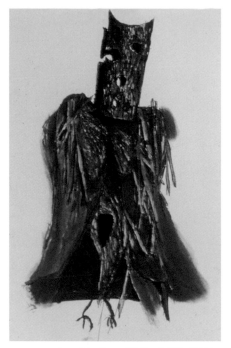

Samuel Mockbee, LIZQUINA: MOTHER GODDESS (LUCY'S PARAMOUR) (sketch), 1993–5

I never knew Mockbee well, but on that sultry summer afternoon, I felt certain that the world described in these pictures was as real, if not more so, to him than the world of projects, grants and classes that had won him so many important and well-deserved accolades. Mockbee was a secret shaman. Alone, he conjured spirits, coaxing them towards the light. In the company of others, he demonstrated how to build a better home.

"Whereas in primate fashion our senses are turned outward to the world at large, the seemingly dull cow has its senses turned inward, into its digestion, 'meditating' on the forces and energies that are fixed into the vegetable kingdom and liberating these forces during digestion. No wonder the cow is sacred in India, for it is the very image of consciousness turned inward upon itself in deepest meditation."
—*Wolf Storl*, Culture and Horticulture: A Philosophy of Gardening

AVERY PREESMAN AND I DROVE TO SEE HIS STUDIO IN THE COUNTRYSIDE NEAR Amsterdam. As we passed fields of cows, the pungent odor of fresh dung filled the car. "That's what art should smell like!" Avery exclaimed. Of all the aesthetic criteria in circulation these days, this is not one frequently heard. Shit: humid, spicy and sweet. Why should art smell like this? Is this a provocation à la Manzoni? I don't think so.

Preesman's painting has more in common with a newly plowed and fertilized field than it does with most of the clever art being made today. For him, painting is equivalent to horticulture, and you need shit to make things grow. Preesman grew this painting: primed the canvas, laid down the paint, scored it, smeared it. Five horizontal layers, divided vertically by a line that wags here and there like the tip of a cat's tail.

Painting is equivalent to horticulture, but it isn't horticulture. It's just that painting is making, making things grow. So is building a house. Which is something Preesman would be doing now if he were still in Curaçao, where he was born. Every young guy there has to build a house. Preesman builds a painting, first the post and then the lintel, then again. It stands up straight, maybe not like a house of brick or stone, but that's not called for in this tropical climate.

Then there's the canals. Canals flow through this painting, or rather, the painting is a canal, a channel, channeling Preesman. He lives by the Amstel, like Rembrandt and

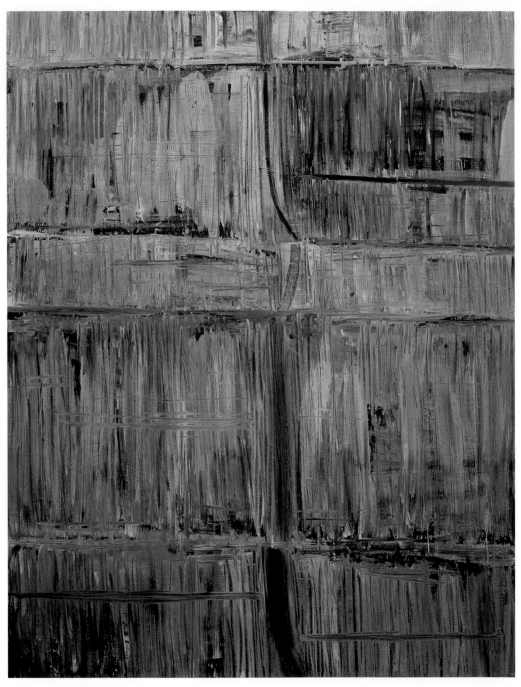

Avery Preesman, UNTITLED, 1998

countless other lucky Dutch painters. It flows smoothly past his studio. Flow, flow, flow. Through parallel banks. And the reflections of trees, of sails. For the Dutch, channeling water is, like ploughing the land, a precursor of richness.

Everything has a beginning that isn't a beginning. Shit is an ending, but also a beginning. Art history is like that. One thing grows out of the next. Almost inevitably. Take Preesman: there's Van Gogh, Cezanne, Klee, Mondrian, Jawlensky, Hartung and Diebenkorn. But more: there's Zurbaran, Chardin, Constable and Pissarro. Don't be afraid of these names. Anyone can plant a field, or build a house, or sail a boat. At least anyone who sets their mind to it. Thinking and doing are all it takes. Thinking and doing are all it takes to paint.

Preesman's painting seems simple. It is flat, little more than two colors: yellow over black. Brushstrokes are mostly horizontal, with quick vertical accents. Simple indeed. But it stares at you like a bull in a field. Simple, yes, but not inconsequential. What is this seriousness, this stalwartness, this strength?

The West remembered abstraction in the twentieth century. What a relief! It's not enough to eat just the outside of things, and we were getting a little anemic. Maybe we even forgot how the world tastes, never mind how it smells. Paint isn't really as "natural" as cow dung: paint has a history; cow dung doesn't. That's important to acknowledge. So let's not pretend that Preesman possesses some kind of primal energy. It's just that he can make a good painting, an abstract painting. An abstract painting is not an image, it's a thing. The more it smells, the better.

Thinking and Doing

Malinda Taniova
Untitled, c. 1994
natural dyes on tapa cloth
22 x 49 in.
Collection of Lawrence Rinder
Photo by Leslie Bauer

Sophie Calle and the Practice of Doubt

Sophie Calle
Patrick X, sixteenth sleeper, detail from *The Sleepers*
(*Les Dormeurs*), 1979
gelatin silver prints with handwritten captions;
printed texts
62 x 162 in., overall
Courtesy Paula Cooper Gallery, New York

Sophie Calle
The Hotel, Room 46, 1986
gelatin silver prints
framed, each panel 41 1/4 x 57 x 1 1/2 in.
Solomon R. Guggenheim Museum, New York
Partial and promised gift, The Bohen Foundation,
2001

Sophie Calle and Greg Shephard
Double Blind, 1992
single-channel video, color, sound, 76 min.
Courtesy Paula Cooper Gallery, New York

Jochen Gerz: The Berkeley Oracle

Jochen Gerz
The Berkeley Oracle: Questions Unanswered
(installation views), 1998
mixed media installation
University of California, Berkeley Art Museum and
Pacific Film Archive, March 27–May 31, 1998.

Knowledge of Higher Worlds: Rudolf Steiner's Blackboard Drawings

Rudolf Steiner
The Birth of the Planet, October 31, 1923
chalk on paper
39 x 59 in.
Rudolf Steiner Nachlassverwaltung, Dornach,
Switzerland

Rudolf Steiner
Hegel and Schopenhauer, December 4, 1920
chalk on paper
39 x 59 in.
Rudolf Steiner Nachlassverwaltung, Dornach,
Switzerland

Rudolf Steiner
*Eurythmie-Choreographie of Henry Longfellow's "The
Arrow and the Song,"* August 1921
ink on paper
Rudolf Steiner Nachlassverwaltung, Dornach,
Switzerland

Rudolf Steiner
The Realm of the Angels, August 3, 1924
chalk on paper
39 x 59 in.
Rudolf Steiner Nachlassverwaltung, Dornach, Switzerland

Joseph Beuys
The Sun State, 1974
chalk on slate
47 1/2 x 72 in.
The Museum of Modern Art, New York, Gift of Abby Aldrich Rockefeller and acquired through the Lillie P. Bliss Bequest (by exchange)
© The Museum of Modern Art/Licensed by Scala/ Art Resource, NY

Rosie Lee Tompkins, Really

Rosie Lee Tompkins
Three Sixes, 1986 (quilted by Willia Etta Graham)
polyester, polyester double-knit, wool jersey
83 x 70 in.
Whitney Museum of American Art
Photo by Sharon Risedorph

Rosie Lee Tompkins
Untitled, 1986 (quilted by Willia Etta Graham)
velvet, velveteen
85 x 77 in.
Collection of Eli Leon
Photo by Sharon Risedorph

Hans Hofmann
Combinable Wall I and II, 1961
oil on canvas
84 1/2 x 112 1/2 in.
University of California, Berkeley Art Museum and Pacific Film Archive,
Gift of the artist
Photo by Benjamin Blackwell

Rosie Lee Tompkins
Untitled, 1996 (quilted by Irene Bankhead)
cotton, cotton flannel, cotton feed sack, linen, rayon, flocked satin, velvet, cotton-synthetic blend,

cotton-acrylic jersey, acrylic double-weave, cotton-polyester, polyester doubleknit, acrylic and cotton tapestry, silk batik, polyester velour, rayon or acrylic embroidery on cotton, wool, needlepoint, shisha-mirror embroidery
88 x 146 in.
Collection of Eli Leon
Photo by Sharon Risedorph

Rosie Lee Tompkins
Untitled, 1987 (quilted by Willia Etta Graham and Johnnie Wade)
velvet, velveteen
55 x 49 in.
Collection of Gwen Head
Photo by Sharon Risedorph

Rosie Lee Tompkins
Untitled *(String)*, 1985 (quilted by Willia Etta Graham)
velvet, velveteen
100 x 86 in.
Collection of Eli Leon
Photo by Sharon Risedorph

Rosie Lee Tompkins
Untitled, 1996 (quilted by Willia Etta Graham and Johnnie Wade)
velvet, velveteen
66 x 50 in.
Collection of Eli Leon
Photo by Sharon Risedorph

Anywhere Out of the World: The Photography of Jack Smith

Paolo Veronese (Paolo Caliari)
Mars and Venus United by Love, c. 1576
oil on canvas
81 x 63 3/8 in.
The Metropolitan Museum of Art, John Kennedy Fund, 1910

Jack Smith
Untitled (detail from contact sheet), 1958–60
color photograph
2 1/4 x 2 1/4 in.
Courtesy The Plaster Foundation

Jack Smith
Untitled (detail from contact sheet), 1958–60
color photograph
2 1/4 x 2 1/4 in.
Courtesy The Plaster Foundation

Jack Smith
Untitled (detail from contact sheet), 1958–60
color photograph
2 1/4 x 2 1/4 in.
Courtesy The Plaster Foundation

Jack Smith
Untitled (detail from contact sheet), 1958–60
color photograph
2 1/4 x 2 1/4 in.
Courtesy The Plaster Foundation

Jack Smith
Untitled (detail from *The Beautiful Book*), 1958–60
black and white photograph
2 1/4 x 2 1/4 in.
Courtesy The Plaster Foundation

Jack Smith
Untitled (detail from *The Beautiful Book*), 1958–60
black and white photograph
2 1/4 x 2 1/4 in.
Courtesy The Plaster Foundation

Jack Smith
Untitled (detail from *The Beautiful Book*), 1958–60
black and white photograph
2 1/4 x 2 1/4 in.
Courtesy The Plaster Foundation

Jack Smith
Untitled (detail from *The Beautiful Book*), 1958–60
black and white photograph
2 1/4 x 2 1/4 in.
Courtesy The Plaster Foundation

Jack Smith
Untitled (detail from contact sheet), 1958–60
color photograph
2 1/4 x 2 1/4 in.
Courtesy The Plaster Foundation

In a Different Light

Romaine Brooks
Peter (A Young English Girl), 1923–24
oil on canvas
36 1/3 x 24 1/2 in.
Smithsonian American Art Museum, Washington,
D.C., Gift of the artist

Catherine Opie
Self-Portrait/Cutting, 1993
Type C print, edition of 8
40 x 30 in.
Courtesy Regen Projects, Los Angeles

General Idea
Baby Makes 3, 1984–89
lacquer on vinyl
78 3/4 x 63 in.
Courtesy AA Bronson

Zoe Leonard
Washington, D.C., 1989
gelatin silver print
23 x 33 in.
Courtesy of the artist and Paula Cooper Gallery,
New York

Fort Thunder, Forcefield and the New York Art World

Brian Chippendale
Untitled, c. 2000
silkscreen print, from *Monster 200*, artist's book,
c. 2000, edited by Leif Goldberg, edition of 200

Fort Thunder print studio, c. 2000
Photo by Brian Chippendale

Brian Chippendale riding a Pete Fuller bike,
c. 2000
Photo by Dave Fischer

Pete Fuller's bikes, c. 2000
Photo by Dave Fischer

Brian Chippendale
Maggots (detail), c. 2000
ink on paper
drawings for graphic novel (forthcoming in 2006
from Load Records)

Forcefield in Concert, c. 2000
Photo by Brian Oakley

Fort Thunder Interior, c. 2000
Photo by Hisham Bharoocha

Fort Thunder Interior, c. 2000
Photo by Hisham Bharoocha

Fort Thunder Interior, c. 2000
Photo by Hisham Bharoocha

Foes and Friendsters: The Drawings of Mark Lombardi

Mark Lombardi
BCCI, ICIC & FAB, 1996–2000
graphite on paper
52 5/16 x 139 in.
Whitney Museum of American Art, New York;
purchase with funds from the Drawing Committee
and the Contemporary Committee

Mark Lombardi
BCCI, ICIC & FAB (detail), 1996–2000
graphite on paper
52 5/16 x 139 in.
Whitney Museum of American Art, New York;
purchase with funds from the Drawing Committee
and the Contemporary Committee

John Currin
The Pink Tree, 1999
oil on canvas
78 x 48 in.
Hirshhorn Museum and Sculpture Garden,
Smithsonian Institution, Joseph H. Hirshhorn
Purchase Fund
Courtesy Gagosian Gallery

Tuymans's Terror

Luc Tuymans
Bloodstains, 1993
22 3/5 x 18 2/3 in.
oil on canvas
Courtesy Zeno X Gallery Antwerp, Belgium
Photo by Felix Tirry

Luc Tuymans
Superstition, 1994
18 2/5 x 16 2/5 in.
oil on canvas
Collection University of California, Berkeley Art
Museum and Pacific Film Archive
Courtesy Zeno X Gallery Antwerp, Belgium
Photo by Felix Tirry

Luc Tuymans
Rear Mirror, 1986
25 1/5 x 74 4/5 in.
oil on canvas
Courtesy Zeno X Gallery Antwerp, Belgium
Photo by Marc Van Geyte

Luc Tuymans
Antichambre (Blauwe Kamer), 1985
25 3/5 x 28 1/3 in.
oil on canvas
Courtesy Zeno X Gallery Antwerp, Belgium

Luc Tuymans
The Arena, 1978
23 4/5 x 30 4/5 in.
mixed media (oil on paper)
Courtesy Zeno X Gallery Antwerp, Belgium
Photo by Dirk Pauwels

Luc Tuymans
Gaskamer, 1986
19 2/3 x 27 3/5 in.
oil on canvas
Courtesy Zeno X Gallery Antwerp, Belgium
Photo by Ronald Stoops

Paul Delaroche
The Death of Cardinal Mazarin, 1830
oil on canvas
22 1/2 x 38 in.
Reproduced by kind permission of the Trustees of
the Wallace Collection, London

Louise Bourgeois: Drawings

Louise Bourgeois
Untitled, 1968
white pastel on red paper
19 3/4 x 25 1/2 in.
Collection Modern Art Museum of Fort Worth
Photo by Zindman Fremont

Louise Bourgeois
Untitled, 1988
watercolor and pencil on paper
11 3/4 x 9 in.
Collection University of California, Berkeley Art
Museum and Pacific Film Archive
Photo by Zindman Fremont

Louise Bourgeois
Untitled, 1987
ink and gouache on blue paper
26 1/8 x 33 5/8 in.
Private Collection
Photo by Zindman Fremont

Louise Bourgeois
Untitled *(St. Sebastienne)*, 1987
ink, watercolor and pencil on paper
24 7/8 x 19 in.
Collection Jerry Gorovoy, New York
Photo by Zindman Fremont

Louise Bourgeois
Throbbing Pulse, 1944
black ink on paper
19 1/4 x 12 3/4 in.
Collection Museum of Modern Art, New York
Photo by Eeva Inkeri

Louise Bourgeois
Untitled, 1946
ink on paper
8 3/8 x 5 1/2 in.
Private Collection
Photo by Zindman Fremont

Louise Bourgeois
Untitled, 1946
ink on paper
8 1/2 x 3 1/2 in.
Collection Wendy Williams, New York
Photo by Christopher Burke

Return from Exile: The Art of Theresa Hak Kyung Cha

Theresa Hak Kyung Cha
Exilée, 1980
film and video installation
University of California, Berkeley Art Museum and
Pacific Film Archive, gift of the Theresa Hak Kyung
Cha Memorial Foundation
Courtesy Generali Foundation Collection, Vienna,
Photo by Werner Kaligofsky

Theresa Hak Kyung Cha
Mouth to Mouth, 1975
video (6 images, video stills)
University of California, Berkeley Art Museum and
Pacific Film Archive
Courtesy Generali Foundation Collection, Vienna

Theresa Hak Kyung Cha
Vidéoème, 1976
video (8 images, video stills)
University of California, Berkeley Art Museum and
Pacific Film Archive
Courtesy Generali Foundation Collection, Vienna

Theresa Hak Kyung Cha
Audience Distant Relative, 1978
six envelopes stamped in ink
9 1/2 x 6 1/4 in.
University of California, Berkeley Art
Museum and Pacific Film Archive, gift of the
Theresa Hak Kyung Cha Memorial Foundation
Courtesy Generali Foundation Collection, Vienna,
Photo by Werner Kaligofsky

Conceptualism at the Millennium

RtMark
Barbie Liberation Organization, 1993
website (detail)

Fabrice Hybert
P.O.F. #3—Swing, 1990
latex rubber, wood and synthetic rope
Courtesy of the Artist

Iñigo Manglano-Ovalle
SAD Light Room (Public Service Full Spectrum
Light Therapy), 1999
painted steel, vinyl, fluorescent lamps, speakers,
compact-disc audio track
installation view, CCAC, San Francisco
Courtesy Max Protetch Gallery, New York

Joseph Grigely
Untitled *Conversations (Susan's Martini Party)*, 1996
framed text and nine sheets of paper
Courtesy Cohan and Leslie Gallery, New York

Martin Creed
Work No. 200: Half the air in a given space, 1998
white 12" balloons; overall dimensions variable
Installation at Galerie Analix B & L Polla, Geneva
Collection Pierre Huber
Work and photo © Martin Creed

Andrea Fraser
A Project in Two Phases (The EA-Generali
Headquaters, Vienna), 1994–95
detail, page from book
© Generali Foundation Collection, Vienna

Silvia Kolbowski
an inadequate history of conceptual art, 1998–1999
video, 55 min., audio, 55 min.
installation view at American Fine Arts,
New York, 1999
Courtesy of the Artist

Silvia Kolbowski
an inadequate history of conceptual art, 1998–1999
video, 55 min., audio, 55 min. (video still)
Courtesy of the artist

Beauty and Theory of Beauty: Irit Batsry's Set

Irit Batsry
Make: Measure 2, from *Set*, 2003
13 sec. (test projection)
from *Set*, 7 continuous digital video projections,
color and black and white, silent. On the south side
of the bridge, Whitney Museum of American Art,
New York.
Courtesy of the Artist

Irit Batsry
Make: Measure 1, from *Set*, 2003
video, 4 min. 30 sec. (2 video stills)
from *Set*, 7 continuous digital video projections,
color and black and white, silent. In the film and
video gallery of the Whitney Museum of American
Art, New York.
Courtesy of the Artist

Irit Batsry
Reflect, from *Set*, 2003
video, 20 min. (video still)
from *Set*, 7 continuous digital video projections,
color and black and white, silent. In the film and
video gallery of the Whitney Museum of American
Art, New York.
Courtesy of the Artist

Irit Batsry
Make: Measure 2, from *Set*, 2003
video, 3 min. 28 sec. (video still)
from *Set*, 7 continuous digital video projections,
color and black and white, silent. In the film and
video gallery of the Whitney Museum of American
Art, New York.
Courtesy of the Artist

Irit Batsry
Setup, from *Set*, 2003
video, 20 min. (video still)
from *Set*, 7 continuous digital video projections,
color and black and white, silent. In the film and
video gallery of the Whitney Museum of American
Art, New York.
Courtesy of the Artist

Irit Batsry
Light, from *Set*, 2003
video, 3 min. (video still)
from *Set*, 7 continuous digital video projections,
color and black and white, silent. In the film and
video gallery of the Whitney Museum of American
Art, New York.
Courtesy of the Artist

Irit Batsry
Make: Measure 2, from *Set*, 2003
video, 3 min. 28 sec. (installation view)
from *Set*, 7 continuous digital video projections,
color and black and white, silent. In the film and
video gallery of the Whitney Museum of American
Art, New York.
Courtesy of the Artist

Kevin Larmon: Painting Sleep, Painting Seduction

Kevin Larmon
Figure #6, 1990
oil and collage on linen
70 x 61 in.
Courtesy of the Artist

Kevin Larmon
A Definition, 1990
oil and collage on canvas
63 x 51 in.
Courtesy of the Artist

Kevin Larmon
Figure #7, 1990
oil and collage on linen
67 x 60 in.
Courtesy of the Artist

Kevin Larmon
Spencertown, New York, 1990
oil and collage on linen
Courtesy of the Artist

In Memory of Samuel Mockbee

Samuel Mockbee and The Rural Studio
The Lucy House (interior), 2001–2
Mason's Bend, Hale County, Alabama
Outreach Studio Project
Photo by Timothy Hursley

Anderson and Lucy Harris and family,
The Lucy House, 2001–2
Mason's Bend, Hale County, Alabama
Outreach Studio Project
Photo by Timothy Hursley

Samuel Mockbee,
Lizquina: Mother Goddess (Lucy's Paramour), 1993–5
drawing on paper
114 x 104 in.
Collection of Jackie Mockbee

Avery Preesman: "Boerenlucht"

Avery Preesman,
Untitled, 1998
oil on canvas
160 x 120 in.
Private Collection, Belgium

The following articles have appeared in slightly different form in previous publications. They have been reprinted here by permission of the author and publishers.

"Thinking and Doing," originally published as "Reed College Commencement Address 2003," Reed College, Portland, Oregon.

"Sophie Calle and the Practice of Doubt," originally published in *Sophie Calle: Proofs* (Hanover, NH: Hood Museum of Art, 1993).

"Jochen Gerz: The Berkeley Oracle," originally published as "Where is my Future?," in *Jochen Gerz: The Berkeley Oracle* (Düsseldorf: Richter Verlag, 1999).

"Knowledge of Higher Worlds: Rudolf Steiner's Blackboard Drawings," originally published as "Rudolf Steiner's Blackboard Drawings: An Aesthetic Perspective," in *Knowledge of Higher Worlds: Rudolf Steiner's Blackboard Drawings*, ed. Lawrence Rinder (Berkeley: University of California, Berkeley Art Museum and Pacific Film Archive, 1997). © The Regents of the University of California. All rights reserved.

"Rosie Lee Tompkins, Really," originally published as "Greatness Near at Hand," in *Rosie Lee Tompkins* (Berkeley: University of California, Berkeley Art Museum and Pacific Film Archive, 1997). © The Regents of the University of California. All rights reserved.

"Anywhere Out of the World: The Photography of Jack Smith," originally published in *Flaming Creature: Jack Smith* (New York: P.S.1 Contemporary Art Center, 1997).

"In a Different Light," originally published in *In a Different Light* (San Francisco: City Lights Books, 1995), catalogue accompanying an exhibition at The University of California, Berkeley Art Museum and Pacific Film Archive, January 11–April 9, 1995.

"Foes and Friendsters: The Drawings of Mark Lombardi," originally published as "Of Friendsters and Foes, The Conspiracy of Mark Lombardi: Crime Fighting Tool—Or 'Just Here to Help'?," in The Village Voice, Vol. XLVII No. 50, Dec. 10–16, 2003.

"Tuymans's Terror," originally published in *Premonitions: Luc Tuymans, Drawings* (Bern: Kunstmuseum Bern, 1997).